IMAGES
of America

GROSSE POINTE
1880–1930

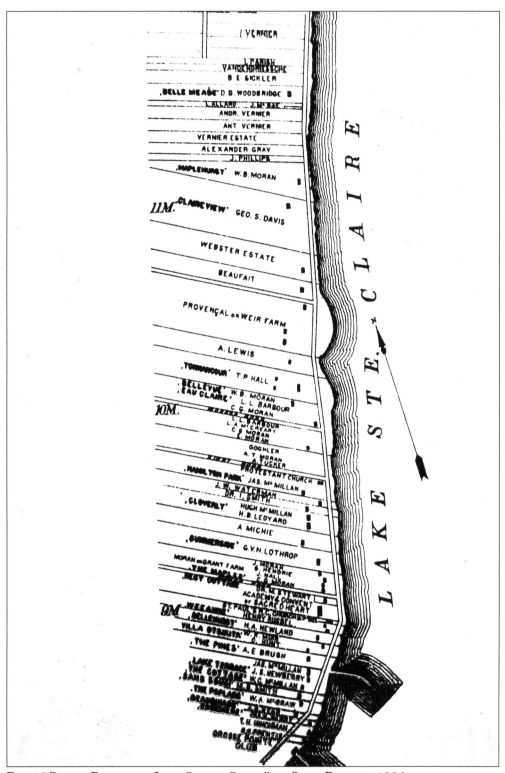

FROM "GROSSE POINTE ON LAKE SAINTE CLAIR," BY SILAS FARMER, 1886.

IMAGES
of America

GROSSE POINTE
1880–1930

Madeleine Socia and Suzy Berschback

ARCADIA
PUBLISHING

Published by Arcadia Publishing
Charleston, South Carolina

Library of Congress Catalog Card Number: 00111843

For all general information contact Arcadia Publishing at:
Telephone 843-853-2070
Fax 843-853-0044
E-mail sales@arcadiapublishing.com
For customer service and orders:
Toll-Free 1-888-313-2665

Visit us on the Internet at www.arcadiapublishing.com

Dedicated to the ones we love!

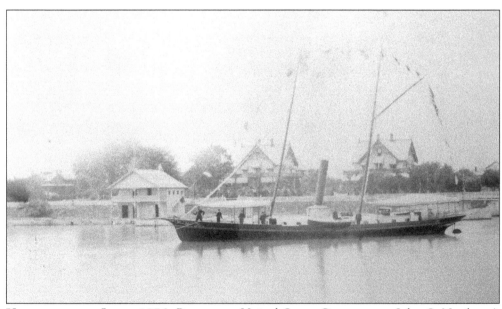

VIEW FROM THE LAKE, 1876. Burgees on United States Congressman John S. Newberry's steam yacht, *Truant*, frame his home and an identical residence belonging to U.S. Senator James McMillan. The two houses, located on Lake Shore Road near Newberry Place, were built in 1875 and referred to jointly as Lake Terrace. (Courtesy of the Burton Historical Collection of the Detroit Public Library.)

CONTENTS

ACKNOWLEDGMENTS

Thank you is such a small phrase for the enormous generosity we have encountered on this project. We would like to gratefully acknowledge the following people for allowing us to use their photographic collections, and sharing their time and talents:

A SPECIAL THANK YOU TO THE GROSSE POINTE HISTORICAL SOCIETY AND THEIR CURATOR, JEAN DODENHOFF.

The Marc J. Alan Family, David W. Allard, The Ignatius Backman Family, The Albert E. Beaupre Family, Bob Berschback, Chip Berschback, Cynthia Bieniek, The Krumholz/Blondell Family, Bruce Bockstanz, Helen Livingstone Bogle, Robert Burkhalter, The Burton Historical Collection of the Detroit Public Library, Kimberly Conely, Cottage Hospital, Sally Cudlip, Defer Elementary School, Danielle De Fauw, The DeRonghe Family, D. R. B. Donavan, The Dossin Great Lakes Museum, The Detroit News/Walter P. Reuther Library/Wayne State University, Lisa Mower Gandelot, The Garska Family, The Grosse Pointe Academy, The Grosse Pointe Club, The City of Grosse Pointe Farms, The Grosse Pointe Historical Society, The Grosse Pointe Hunt Club, The Grosse Pointe Park Department of Public Safety Archives, The Grosse Pointe Public School System, The Village of Grosse Pointe Shores, The Grosse Pointe War Memorial Association, The Grosse Pointe Yacht Club, Nancy Dodge Heenan, Henry Ford Museum/Greenfield Village Archives, Hickey's Walton-Pierce, Dave Hiller, Jay F. Hunter, Chas. F. Irish Company, Marilyn King, Mary Anne LaHood, Manning Brothers Historic Photograph Collection, The J. Moran Family, The National Archives, J. Kelly Burke Oliver, Russel "Forest" Piche, The Sisters of Bon Secour Hospital, Frank Sladen, Jr., The SmithGroup Inc., Patrick Socia, Phyllis Socia, Catherine Watko Staperfenne, Andrea K. Sullivan, Dorothy Loveley Sweeney, Trombley Elementary School Library, The University of Liggett School, Ted Vernier, Fred Wessell, and George O. Young Jr.

INTRODUCTION

The Kodak's come to Tonnancour and with it days of woe,
We do our best to stand it, we've nowhere else to go,
And so we try to bear it, and pray it's but a phase,
For Marie—little Marie Hall—has caught the camera craze.
Excerpted from "A Protest from the Camera Victims to the Camera Fiend"
By Theodore Parsons Hall

Inspired by the natural beauty and man-made splendor of Grosse Pointe's summer colony, it was small wonder that little Marie Hall would want to capture the nearly picture-perfect life that she enjoyed at her family's gingerbread cottage Tonnancour. After all, there was so much to see in the Grosse Pointe of the 1880s, as the quaint French farming and fishing village, located just 7-miles northeast of Detroit on the shores of Lake St. Clair, commenced its ascent into the ranks of America's premier "snubburbs."

The promise of cool lake breezes and picturesque views prompted Marie Hall's family to join other prominent Detroiters in traveling to the Pointe, via carriage or steam yacht. Along the old River Road, the trip took approximately two hours; but the escape from the hustle, bustle, and scent of the city was worth the effort.

Funded by fortunes made in lumber, mining, iron, stove building, railroads, and other boom industries, rambling summer homes began to decorate the emerald edges of the glistening heart-shaped lake in the mid 1850s. There, from June until September, the children frolicked in open fields, splashed in the waters and reveled in the joys of country life while their parents introduced such elite pleasures as golf, tennis, and polo to the Pointe.

As the summer colony expanded, these elegantly appointed cottages replaced many of the original French and Belgian "ribbon farms." Named for their long, narrow configuration, these claims dated back to the early 18th century. They were generally 1.5 miles deep with 500–800 feet of access to the water. The property lines of these farms, along with those of the estates established years later, give Grosse Pointe streets their unique patchwork pattern. When the farms began to shrink, so did the rich Norman culture, which had dominated the French-speaking community for almost a century.

With roots dating to the mid-17th century, Grosse (French for large) Pointe is among the oldest communities in the Midwestern United States. Life in the region has always revolved

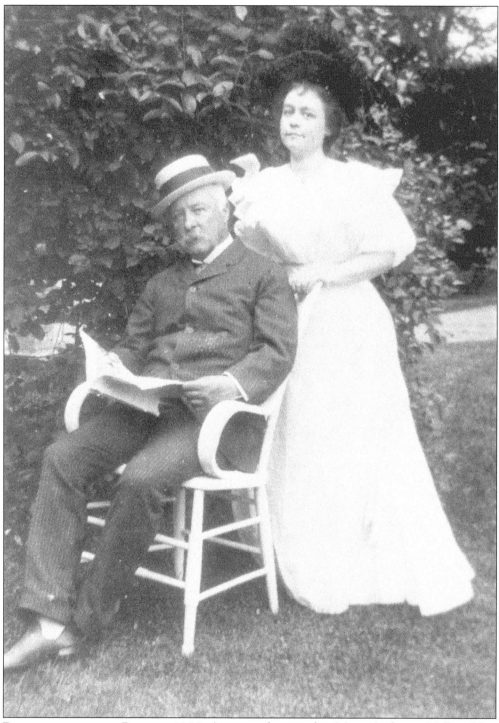

PHOTOGRAPHER AND POET, C. 1892. Amateur photographer Marie Archange Hall and her poetically doting dad, Theodore Parsons Hall, at their summer home Tonnancour, on Lake Shore Road and Tonnancour Place in Grosse Pointe Farms. (Courtesy of the Grosse Pointe Historical Society.)

around Lake St. Clair, part of the Great Lakes system linking Lake Huron to the north with Lake Erie to the south. From ancient times, its beaches provided camp sites to Native-American tribes on hunting and trading expeditions, including the Fox, Miamis, Hurons, Chippewas, Ottawas, and, later, the Potawotomi.

In 1669, French explorer Adrien Joliet was thought to be the first European voyager to pass by the densely wooded shores of the Pointe. Ten years later, the armed merchant vessel, *The Griffin*, under the command of Robert Cavalier de La Salle, sailed up the Detroit River into waters the natives called *Otsikita*, or Salt Lake. Because they passed through on August 12, the feast of Sainte Claire, the ship's Roman Catholic chaplain, Father Hennepin, christened the lake in her honor.

Throughout the early 18th century, French trappers would venture from Fort Pontchartrain du Detroit, founded in 1701, to the Pointe via canoe in search of beaver pelts. As the region's population grew, French, and later British land grants also reached northward to the Pointe. By 1796, when the flag of the United States was raised over the territory, the wilderness was well on its way to becoming a close-knit community of French "habitants," many of whose descendants still reside in the Pointes.

Hard work and strict Roman Catholic traditions dominated daily life, while tall tales enlivened many an evening. The fog-shrouded *Grand Marais*, or Great Swamp, provided fertile ground for folklore. The area was said to be haunted by the tortured souls of more than 1,000 Fox Indians who perished in a fierce battle with French troops in 1712. Other residents claimed to see evil spirits in the ruins of the gristmill there, from which the present day Windmill Pointe neighborhood takes its name. Wide-eyed children also shivered away many candlelit nights listening to tales of the demon horseman Le Lutin or Le Loup Garou, Grosse Pointe's very own werewolf!

But the city slickers, who quickly added a gilt edge to the image of Grosse Pointe, had little taste or time for manual labor or local lore … they were just too busy having fun!

If Detroit was characterized as "The Paris of the Midwest" at the turn of the 20th century, then Grosse Pointe was the Riviera. The wealthy colonists founded private clubs where they could pursue their polite pleasures away from the honky-tonk atmosphere of the area roadhouses, which shared the shoreline.

Boasting chicken, fish, and frog leg dinners along with modest accommodations, roadhouses opened the pleasures of the Pointe to the masses. They also offered a variety of diversions including dancing, gambling, and cockfighting. The spirit of madcap fun reached rare heights at the Moran House, at Lake Shore Road and Moran Road in Grosse Pointe Farms. There a guy could take advantage of a unique opportunity to impress his best gal and win cash prizes by diving into an enclosed pen in the Lake and wrestling a 100-pound sturgeon to the surface!

Improved roads, transportation, education, and city services convinced many summer colonists to make Grosse Pointe their permanent, year-round address. Cottages were replaced with palatial architectural gems set amidst acres of meticulously manicured gardens.

Eventually, the "old money" establishment was joined by newly minted millionaires of Detroit's emerging auto industry, including John and Horace Dodge and, later, Edsel Ford, son of Henry Ford. Chauffeurs were added to the household staffs, many of which also included housemaids, nursemaids, laundresses, and gardeners.

As the good times rolled into the 1920s, residents celebrated life, and seldom let a little thing like the 18th Amendment put a damper on their cocktail consumption. Grosse Pointe became a favorite landing spot for rumrunners servicing the "Detroit Windsor Funnel." This system of importing booze from neighboring Windsor, Ontario, Canada, over the international waters accounted for an estimated 75 percent of the liquor smuggled into the United States during Prohibition. Local law enforcement generally turned a blind eye on the area's thriving speakeasies.

Increases in population, temperance laws, and other factors led to the incorporation of five separate, linked municipalities including the City of Grosse Pointe Park, the City of Grosse Pointe, the City of Grosse Pointe Farms, the Village of Grosse Pointe Shores and the City of Grosse Pointe Woods.

Much to the bemused chagrin of current residents, the glory days of the great estates still fuel the Pointes' pretentious reputation. In reality, however, after the Great Depression and World War II, most were relegated to wistful memory.

While the magnificent mansions may have been built to last forever, the fortunes and social order that created them were not. Though some estates still exist among the tree-lined streets of custom-built homes that now define the Pointes, most fell victim to time and economics. Income tax, inflation and bequests diluted many of the fortunes that built them. In addition, their large staffs were lost to Social Security taxes, minimum wage laws, and the G.I. Bill, which enabled future generations of local domestics to attend college and become upwardly mobile professionals. Many mansions were dismantled before demolition, allowing their architectural details to be incorporated into other homes. Properties were subdivided into elegant residential enclaves.

As one matron lamented when asked about the fate of her Lake Shore Road mansion, "The children aren't interested. They don't want the problem. And if I wanted to put it on the Historic Register, I would have to fix the plumbing and the electricity. I don't have the money to do that. So it will be torn down, as all the rest."

You can still find estate names on street signs next to the names of the founding French and Belgian families and the old summer homes. But the only real way to experience Grosse Pointe's past is through photographs. Thanks to little Marie Hall and other "camera crazed" Pointers who captured the grace and rhythms of their time, we can share this beautiful, bygone vision of gilded Grosse Pointe.

Author's Note: All street names are listed according to current Grosse Pointe maps, although some have changed, or did not yet exist, when these photographs were taken between 1880 and 1930. The only exception to this rule is Lake Shore Road. From Barrington Road in Grosse Pointe Park, to Fisher Road in the City of Grosse Pointe, Lake Shore Road is called Jefferson Avenue. Through Grosse Pointe Farms and Grosse Pointe Shores, that same road is referred to as both Lake Shore Road and Lakeshore Drive. In order to avoid confusion, we will use Lake Shore Road throughout in describing locations in these municipalities. In addition, the spelling of various surnames differ in various generations and branches of some families.

One

DOWN ON THE FARM

COME, CHILDREN, C. 1900. Mrs. Frederick B. Schwartz gathers her children Clarence, Mary Rose, and Dorothy, in view of an unknown lady friend, at the Schwartz home. (Courtesy of the Grosse Pointe Historical Society.)

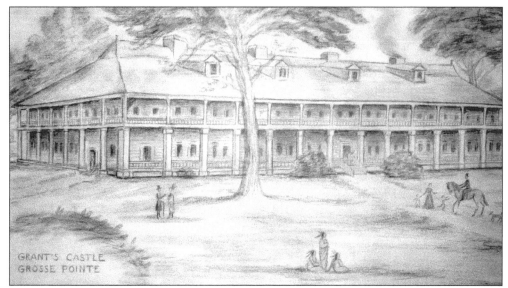

GRANT'S CASTLE, C. 1775. In 1775 native Scotsman Alexander Grant, Commodore of the British Fleet on the Upper Great Lakes, and his wife, Therese Barthe, built this 160-foot-long house made of oak beams as a home for their 13 children. The great house stood on a ridge stretching along Lake Shore Road from Lewiston Road to Lothrop Road in Grosse Pointe Farms. From his estate, Commodore Grant distributed British bounties and pensions to the Indian allies of King George II. It was reported that his guests included the great Indian chief Tecumseh. The house was demolished around 1880. (Courtesy of the Grosse Pointe Historical Society.)

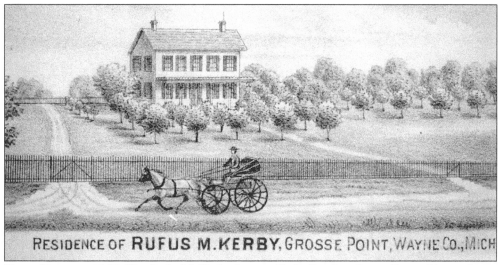

KERBY FARM, C. 1850. The Rufus M. Kerby farm on Kerby Road in Grosse Pointe Farms, shown in an etching from the *Illustrated Historical Atlas of Wayne County*, was the picture of mid-19th century prosperity. Rufus's grandfather, John Kerby, was among the first wave of Americans who emigrated from the east to the Pointes around 1790. This property belonged to John's in-laws, the Donaldson family. It passed to Rufus in 1863 through a series of bequests. Along with the property, the Kerbys were said to have owned a slave named Pompey—one of a number known to have lived and worked in Grosse Pointe Township. Settlers also bought white captives from local Indian tribes, but they were often set free. (Courtesy of the Grosse Pointe Historical Society.)

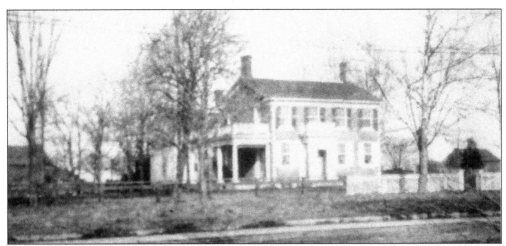

BUILT TO LAST, C. 1913. Believed to be the oldest brick house in the Grosse Pointes, this typical Michigan Greek Revival home at Jefferson Avenue and Three Mile Drive in Grosse Pointe Park, was built in 1849 on the prosperous 210-acre farm of William Buck. The bricks may have come from a clay deposit and kiln once located at the foot of Rose Terrace in the City of Grosse Pointe. The greatly expanded home, occupied by the Harold Wardwell family from 1912 to 1976, remains a private residence known as the Buck-Wardwell House. (Courtesy of the Grosse Pointe Historical Society.)

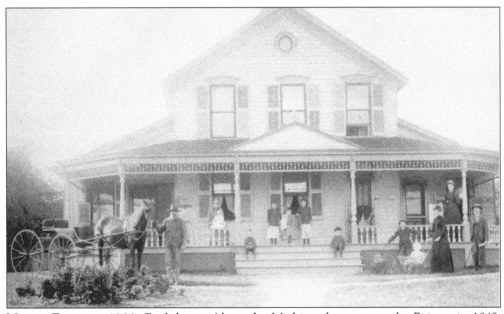

MICHIE FARM, C. 1880. Englishman Alexander Michie, who came to the Pointes in 1849, built this comfortable home for his family on Lake Shore Road near Lothrop Road in Grosse Pointe Farms. Michie, a one-time State Senator, Wayne County Auditor and Postmaster, was also instrumental in organizing the Pointes' first Protestant congregation. Later generations of his family owned a popular roadhouse called Joe Michie's Beach House. This favorite watering hole for yachtsmen from the Detroit Yacht Club and the Detroit Boat Club was located in the center of the present day Neff Park in the City of Grosse Pointe. (Courtesy of the Grosse Pointe Historical Society.)

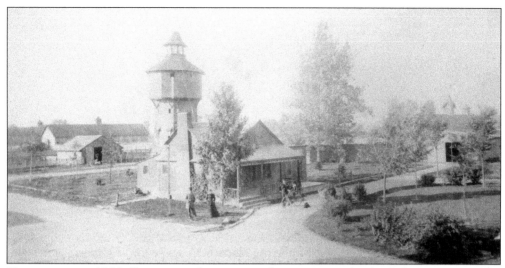

CLAIREVIEW, C. 1890. Summer residents were welcome to visit the docile Jersey cows on the Claireview Stock Farm, located on the country retreat of George S. Davis, one of the founders of the pharmaceutical firm of Parke-Davis and Company, on Lake Shore Road near Clairview Road in Grosse Pointe Shores. The long cow barn, seen in the upper left portion of this picture, was later moved to the Grosse Pointe Hunt Club where it houses horses to this day. Several cottages on the property were also moved inland and are currently in use. (Courtesy of the Burton Historical Collection of the Detroit Public Library.)

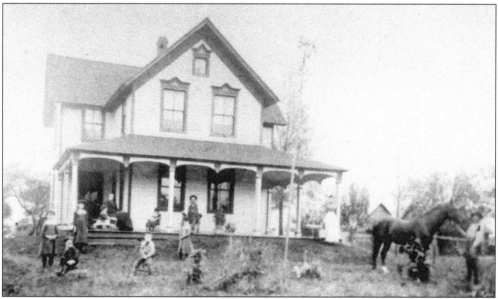

BEAUFAIT FARM, C. 1890. Moments of relaxation were few and far between for Grosse Pointe's hardworking French farmers, like the Theodore Beaufait family, (from left to right) Theresa "Tessie," Mary Jane Lennon Beaufait, Matilda, Joseph (on the velocipede), Catherine Elizabeth, Vera and Theodore. This house was located at Mack Avenue and Vernier Road in Grosse Pointe Woods, near the present site of Parcells Middle School. It was constructed by friends and neighbors during a traditional "building bee." (Courtesy of the Mr. and Mrs. Albert E. Beaupre Family Collection.)

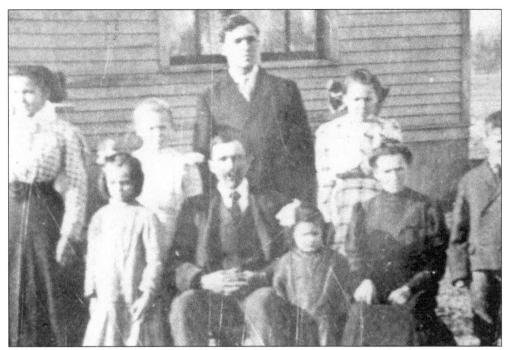

FIRST FAMILY, C. 1909. The Victor Trombley family pose on their 63-acre farm at Mack and Whittier in Grosse Pointe Park. The Trombleys' ancestors are recognized as the first French family to settle permanently in the Pointes. Brothers Pierre, Augustin and Ambrose, set up housekeeping along the Grand Marais, now Grosse Pointe Park, in 1750. Many of their descendants still live in Grosse Pointe. (Courtesy of the Ted Vernier Collection.)

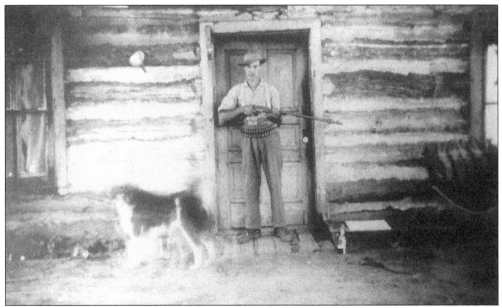

COZY CABIN, C. 1910. Though it looks a lot like a scene from the wild, wild west, gun-toting Leon Van Trosster Berghe's cabin was located on Mack Avenue near Rivard Boulevard in the City of Grosse Pointe. (Courtesy of the Grosse Pointe Historical Society.)

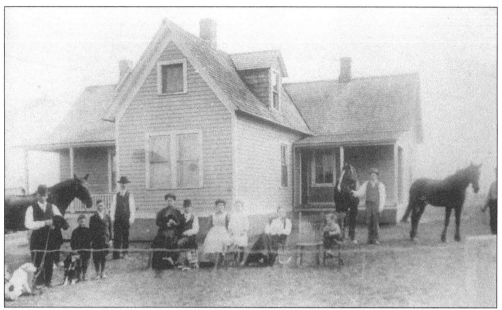

THE OLD HOMESTEAD, C. 1911. A small gathering of Pontiff and Theresa LaForest Allard's 19 children at their homestead, near the southeast corner of Mack Avenue and Moross Road in Grosse Pointe Farms. (Courtesy of the David W. Allard Collection.)

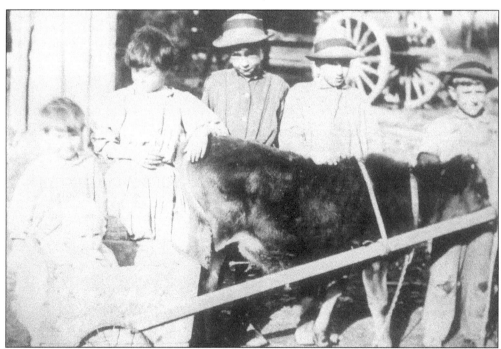

MOOOOOOVE! C. 1911. The children of innkeeper/house mover Henry Krumholz Blondell hitched their calf to a cart in hopes of giving their baby brother a memorable ride. They were playing in the yard behind the Weaver House Roadhouse, on Lake Shore Road between St. Clair Avenue and Notre Dame Street in the City of Grosse Pointe. (Courtesy of the Krumholz/ Blondell Family Collection.)

POUPARD PORTRAIT, C. 1880. Simon Poupard and his wife Genevieve Beaubien Poupard raised their family on a farm, purchased in 1860, which spanned most of Yorkshire Road in Grosse Pointe Park. The property was subdivided in 1915. (Courtesy of the Grosse Pointe Historical Society.)

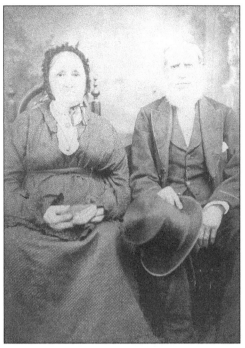

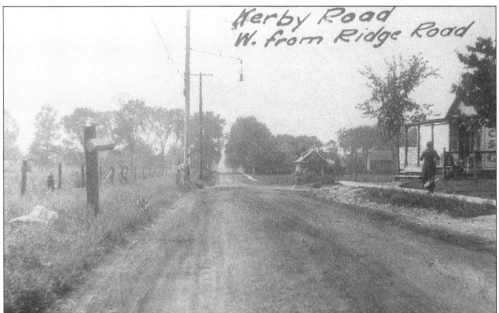

KERBY ROAD, C. 1920. The Kerby family, who arrived in the Pointes in the early 19th century, became prosperous farmers, fishery owners and, in the case of young George Kerby, proprietor of the confectionery store shown in the right of this photo. In the late 19th century, the area shown to the left side of this picture, near the present site of Voltaire Place, was called Hamilton Park. The 50-acre parcel owned by James McMillan, was used as a horse-racing track, six-hole golf course and baseball field. It takes its name from Mr. McMillan's birthplace, Hamilton, Ontario, Canada. (Courtesy of the Ignatius Backman Family Collection/City of Grosse Pointe Farms.)

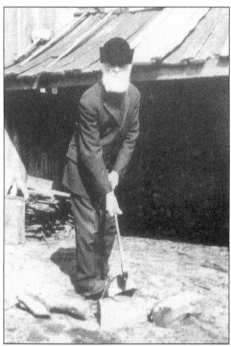

TWICE WARMED C. 1926. Though well over 90 years old, Theodore Louis Beaufait chopped wood to warm the parlor of his farmhouse on Mack Avenue and Vernier Road in Grosse Pointe Woods. The farm included the property where Parcells Middle School now stands. His wife was Mary Jane Lennon Beaufait, for whom Lennon Road in Grosse Pointe Woods is named. (Courtesy of the Mr. and Mrs. Albert E. Beaupre Family Collection.)

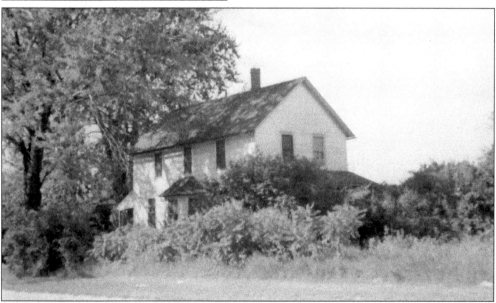

FROGS AND BUFFALOES, C. 1925. The Vanderbush farmhouse, located on Morningside Drive in Grosse Pointe Woods, was home to a family known for providing Pointers with fresh corn and produce from the 1880s through the 1950s. In 1964, the Grosse Pointe Board of Education negotiated to purchase 32 acres of the site for nearly $1 million, making way for the construction of Grosse Pointe North High School, which opened in 1968. The Vanderbushes were among many Belgian farmers and skilled craftsmen who settled in the Pointes in the mid 19th century. The Pointe's old French families jokingly referred to the "newcomers" as "buffaloes" while the Belgian settlers returned the volley by calling their Franco-American neighbors "frogs." (Courtesy of the Grosse Pointe Historical Society.)

Two

HOT TIME IN THE OLD TOWN TONIGHT

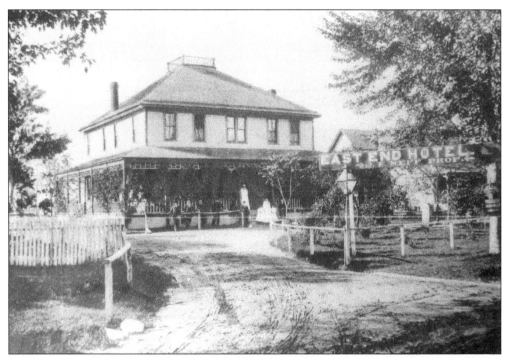

GUNS AND GAMBLING, C. 1888. Members of the Grosse Pointe Gun Club gathered regularly at John F. Neff's East End Hotel, at Lake Shore Road and Neff Road in the City of Grosse Pointe. There they practiced shooting at political banners posted on tall stakes out in Lake St. Clair. They also tested their luck on the establishment's slot machines. In 1908, the Hotel became Doerr's Inn, where area couples spent many a romantic evening dancing to a live orchestra. Before being demolished in 1936, the building was padlocked as a speakeasy. (Courtesy of the Burton Historical Collection of the Detroit Public Library.)

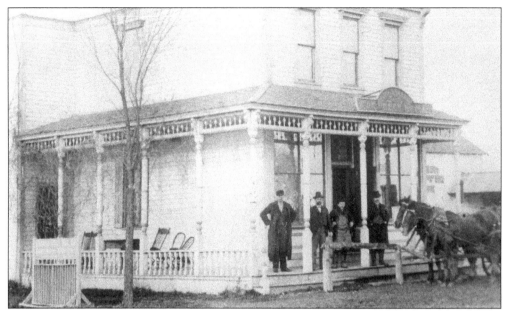

FOX CREEK HOUSE, C. 1890. Located at Alter Road and East Jefferson Avenue in the Village of Fairview, now part of Grosse Pointe Park, John Garska's saloon was a favorite stop for travelers on their way to and from the Pointes. Guests could enjoy a hearty sandwich and a cold beer for a nickel. Prohibition closed the establishment in 1918. The Garska family later donated the land behind their establishment to St. Ambrose Parish, founded in 1916. (Courtesy of the Garska Family Archives.)

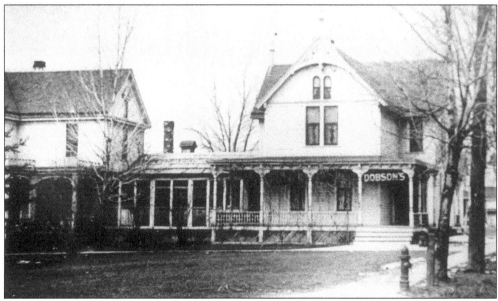

DOBSON'S INN, C. 1890. In 1890, William "Billy" Dobson bought this Roadhouse, located at Jefferson Avenue and Fisher Road in the City of Grosse Pointe, and installed slot machines. He operated it as a popular sportsman's hangout until 1900. After being purchased by a real estate syndicate, it was sold to the City of Grosse Pointe. (Courtesy of the Grosse Pointe Historical Society.)

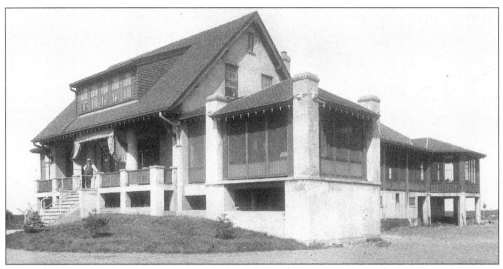

MATT KRAMER'S ROADHOUSE, C. 1910. After taking over the old Oxenhart House at Kensington Road and Jefferson Avenue in Grosse Pointe Park in 1897, Matt Kramer operated Road House II until 1910, when the property became part of Detroit clothier E.J. Hickey's estate. He then moved his operation north, to this building on Lake Shore Road and Gaukler Pointe in Grosse Pointe Shores, where he was proprietor of an inn until 1917. (Courtesy of the Detroit News Collection/Walter P. Reuther Library Wayne State University.)

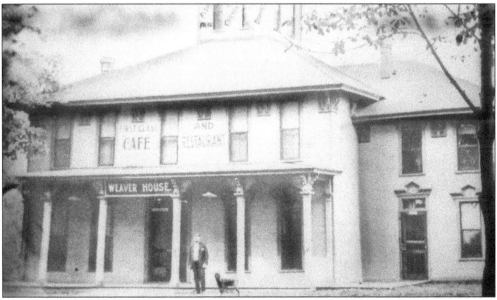

WEAVER HOUSE, C. 1910. One of the Pointe's most popular innkeepers was former circus strongman Henry Krumholz Blondell, pictured in front of the Weaver House, built in 1875 at the corner of Jefferson Avenue and Notre Dame in the City of Grosse Pointe. Blondell, who ran the establishment from 1901 to 1918, delighted patrons with nightly exhibitions of his powers . . . tearing telephone books, bending iron bars with his neck and folding nickels, dimes and quarters with his fingers. Together with his equally strapping sons, Blondell moonlighted moving large residential and commercial buildings, intact, to new sites around the Pointe. (Courtesy of the Krumholz/Blondell Family Collection.)

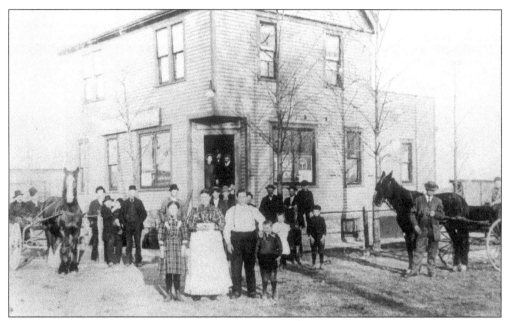

VanDamme's Half-Way House, c. 1910. Local Belgian families flocked to Levin VanDamme's Roadhouse, built in 1909 on the corner of Mack Avenue and St. Clair Avenue in the City of Grosse Pointe, for homing pigeon races and gambling. After VanDamme retired, the building was leased to "Kid" Harris, then sold to Johnny Ryan, who ran a gambling club there until 1923. (Courtesy of the Grosse Pointe Historical Society.)

Catch of the Day, c. 1910. In 1888, John Vernier, son of one of the Pointe's great French pioneer families, opened the Vernier Roadhouse and Hotel at Vernier Road and Lakeshore in Grosse Pointe Shores. In 1895, he sold it to his cousin Ed Vernier who moved the operation to a more substantial building on the northwest side of Vernier Road. By 1915, this facility included a large pier where members of the Grosse Pointe Ice Boat Club, a forerunner of the Grosse Pointe Yacht Club, rallied for races. (Courtesy of the Grosse Pointe Historical Society.)

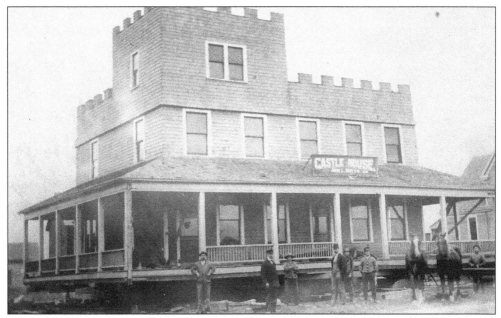

A MOVING EXPERIENCE, C. 1910. Moving day for The Castle House, a frame "roadhouse" built in 1900 by Paul Rivard on the northwest corner of Maumee Road and University Place in the City of Grosse Pointe. Henry Termott was the innkeeper and manufactured cigars from tobacco grown behind the building. Belgian families made the Castle House the headquarters of the William Tell Archery Club from 1906 to 1910. It was moved on wooden rollers to a site near St. Clair Avenue and Charlevoix Road in the City of Grosse Pointe and was later demolished to make way for Elworthy Field. (Courtesy of the Blondell Family Collection.)

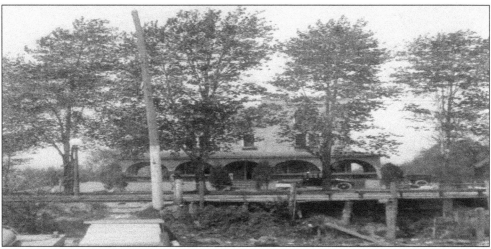

COCK TAILS AND DANCING, C. 1914. Placing big bets on cockfights and dancing to live orchestra music were the chief attractions at the Veriden Roadhouse situated on Lake Shore Road near Provencal Road in Grosse Pointe Farms. Charles Veriden (n. Verheyden) first established a roadhouse at Lakeshore Drive and Cook Road in 1886. After fire destroyed the original, this bigger, better version, was operated by Charles's brother, Frank Veriden, from 1902 to 1910. When Joseph B. Schlotman purchased the property in 1915 for his Stonehurst estate, the building was demolished. (Courtesy of a Private Collection.)

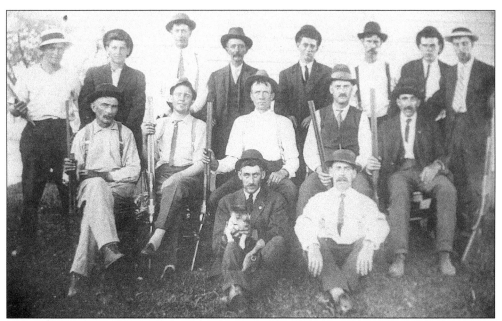

SURE SHOTS, C. 1915. These Pointe marksmen gathered for a little friendly competition at the Blue Rock Shooting Club, located on nearby Bluehill Road in Detroit. Pictured here are (front row) William Weigand and George Chauvin; (middle row) Ed Gifford, Joe Crum, Walter Fresh, Isadore Chauvin and Victor Trombley; (back row) Delbert Gieche, Mr. Whitmore, Joe Fresh, Mr. Herbert, Brown Herbert, Jim Couture, Louis DuLac and Steve Van Tiem. (Courtesy of the Ted Vernier Collection.)

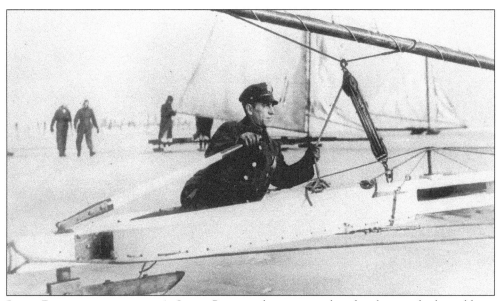

ICING RUMRUNNERS, C. 1925. Grosse Pointe policemen employed iceboats, which could run as fast as 70 miles per hour, to chase rumrunners who drove their contraband-Canadian-cargo across the frozen surface of Lake St. Clair during prohibition. Eventually, trigger-happy federal law officials generated as much fear and disgust as the smugglers they pursued. This contributed to local support for the repeal of the Volstead Act. (Courtesy of The National Archives.)

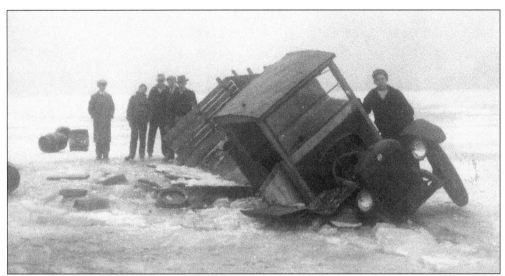

BEER ON ICE, C. 1928. This bootlegger's truck hit a patch of thin ice while crossing Lake St. Clair, but their misfortune seems an exception to the rule. So many rumrunners were successful in their mission that it was estimated that some 75 percent of the liquor supplied to the United States during Prohibition passed through the waters of the St. Clair River, Lake St. Clair and the Detroit River (known as "the Detroit/Windsor Funnel"). (Courtesy of the Detroit News Collection/Walter P. Reuther Library, Wayne State University.)

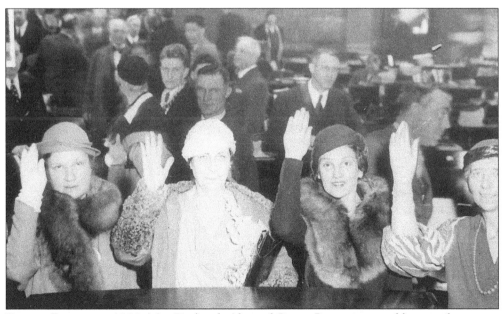

REPEAL REBELS, C. 1928. Mrs. Frederick Alger of Grosse Pointe, pictured here in the center, voted in support of Prohibition repeal. Mrs. Alger headed the Detroit chapter of the Women's Organization for National Prohibition Reform, one of the country's most powerful advocacy groups. Her attitude toward the issue reflected that of many other prominent Pointers, who were tired of the violence created by Prohibition. In addition, few Pointers were willing to let the law put a damper on their cocktail parties or nightly nips at numerous area speakeasies. (Courtesy of the Burton Collection of the Detroit Public Library.)

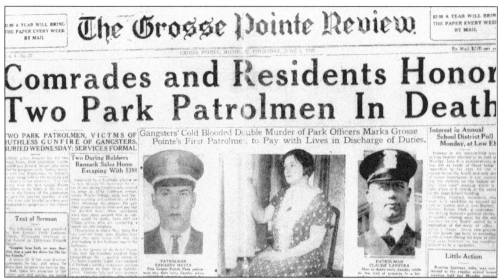

IN THE LINE OF DUTY, C. 1930. The gangland violence of Prohibition shattered the early morning silence of June 1, 1930, when Grosse Pointe Park Police Patrolmen Erhardt Meyer and Claude Lanstra were gunned down in front of the Grosse Pointe Park Police Department on E. Jefferson Avenue and Lakepointe Road. A hail of 25 bullets killed the officers as they attempted to pursue a bootlegger's car, which had been involved in a hit-and-run earlier that evening. This incident reinforced the unofficial "hands-off" policy toward rumrunners generally accepted by Pointe law enforcement agencies. (Courtesy of the Grosse Pointe Park Department of Public Safety Archives.)

FROM RUMRUNNER TO RESTAURATEUR, C. 1930. Prohibition launched the successful career of Albert M. "Al" Green, who came to Detroit from Chicago in 1921 at the age of 19. Green and his wife "Torchie" opened the Pointe's most famous speakeasy, The Pines, in a weather-beaten clapboard farmhouse in the old Pine Woods picnic area, at Lothrop Road near Ridge Road in Grosse Pointe Farms. There customers in black tie and blue collars hoisted a few with Al. Instead of being demolished, The Pines was later encapsulated in a modern house on the site. By the time of his death in 1967, Green was chairman of the board of a 17-state catering operation servicing airlines, industries and Detroit's Cobo Hall. He also owned two restaurants in the Pointes. (Courtesy of the Detroit News Collection/Walter P. Reuther Library, Wayne State University.)

Three

IN THE GOOD OLD SUMMERTIME

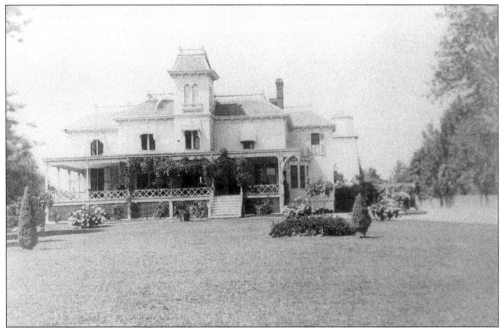

OTSIKITA VILLA, C. 1880. After several seasons of "summering" in the Pointes, railway executive/manufacturer/philanthropist William Kerr Muir decided to move his family there permanently in 1882, setting a trend eventually followed by his wealthy Detroit neighbors. His estate, located on Lake Shore Road near Muir Road in Grosse Pointe Farms, was named for the Huron Indian word for Lake St. Clair, meaning sugar or salt. (Courtesy of the Jay F. Hunter Collection/Grosse Pointe Historical Society.)

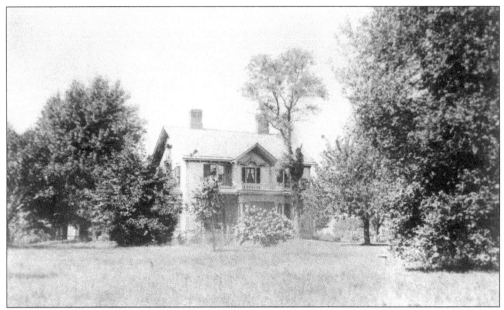

SUMMERSIDE, C. 1850. George V. N. Lothrop, a prominent Detroit attorney and United States Minister at St. Petersburg, Russia, is recognized as one of the founders of Grosse Pointe's summer colony. He purchased 130 acres of land on Lake Shore Road near Lothrop Road in Grosse Pointe Farms in 1850 and built this comfortable clapboard cottage named Summerside. (Courtesy of the Grosse Pointe Historical Society.)

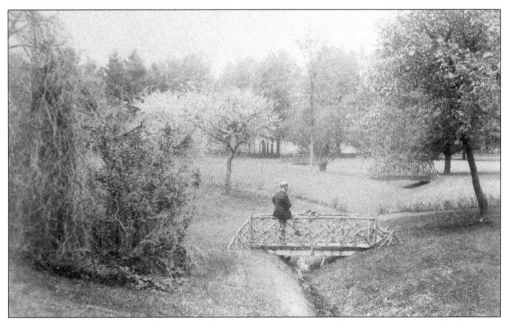

AT THE PINES, C. 1900. A dapper gentleman enjoys a contemplative moment on a bridge over one of the picturesque ravines on Alfred E. Brush's 35-acre summer property, The Pines, located at Lake Shore Road and Briarwood Place in Grosse Pointe Farms. Alfred's father, Edmund A. Brush, purchased the land in 1857, making him one of the premier members of the Pointe's summer colony. (Courtesy of the Grosse Pointe Historical Society.)

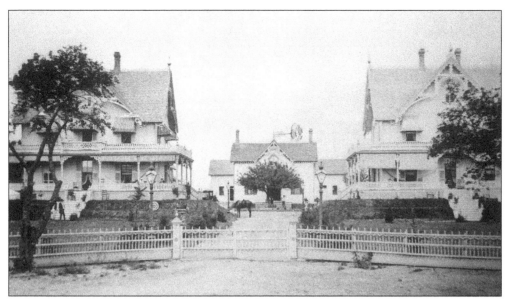

LAKE TERRACE, 1876. These twin Swiss chalets, owned by close friends and founders of the Michigan Car Works, United States Congressman John S. Newberry and U. S. Senator James McMillan, were built in 1875. The long dock fronting the property, located on Lake Shore Road near Newberry Place, was constructed in cooperation with neighbor Alfred E. Brush. Moored there were the Newberry steam yacht, Truant, Brush's yacht, Lillie and the Leila, a shuttle owned by a dozen other residents. These yachts were employed not only for pleasure, but also as an elegant and convenient means to commute to their owners' downtown Detroit offices. (Courtesy of the Burton Historical Collection of the Detroit Public Library.)

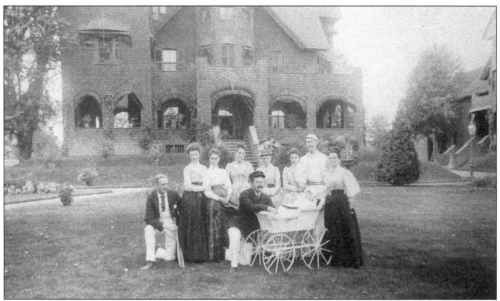

LAKE TERRACE RENOVATION, 1895. Mr. and Mrs. Truman H. Newberry pose with their child and unidentified others in front of the John S. Newberry house, which together with the neighboring "twin" residence of Senator James McMillan, was remodeled in the shingled style in vogue in the Pointes. (Courtesy of the Burton Historical Collection of the Detroit Public Library.)

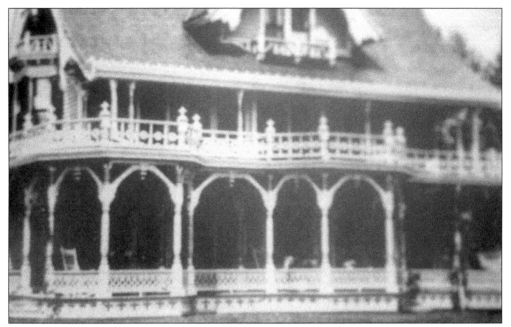

TALES OF TONNANCOUR, C. 1900. In 1880, banker, grain merchant, and United States Courts Commissioner Theodore Parsons Hall built this whimsical Swiss chalet summer home on 63 acres at Lake Shore Road and Tonnancour Place in Grosse Pointe Farms. This particular parcel was the setting for local lore. As legend states, in the late 17th century a thwarted lover sold his soul to the devil for the power to transform himself into a werewolf or, in French, Le Loup Garou. While assuming this evil form, he attempted to kidnap the object of his desire as she prayed at a shrine on the beach. Heeding the young girl's prayerful pleas, some heavenly force turned Le Loup Garou to stone before he could complete his terrifying mission. Delighted with her property's storied past, Mrs. Hall erected a shrine, complete with a carved stone werewolf, on the beach at Tonnacour. (Courtesy of the Grosse Pointe Historical Society.)

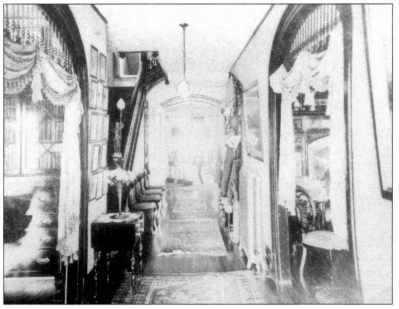

ELEGANT INTERIOR, C. 1900. All the comforts of city life adorned the elegant interior of Tonnancour. Hall built the Swiss chalet in 1880 and enjoyed many summers there with his wife and seven children. (Courtesy of the Grosse Pointe Historical Society.)

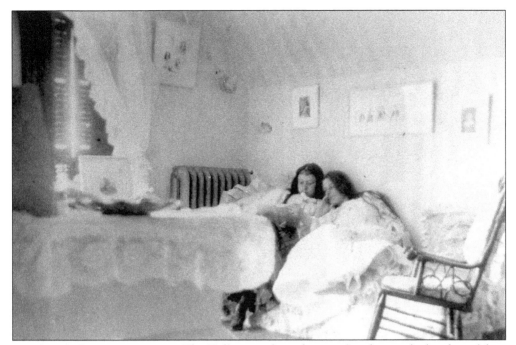

THE JOY OF READING, C. 1892. The Hall sisters share the joy of reading in the boudoir of their summer home Tonnancour. (Courtesy of the Grosse Pointe Historical Society.)

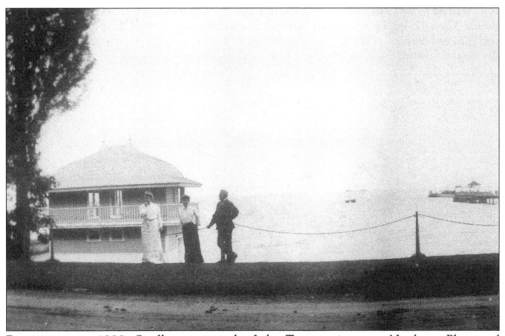

PANORAMA, C. 1880. Strollers gaze at the Lake Terrace pier, near Newberry Place and Lake Shore Road in Grosse Pointe Farms. To their left is one of numerous picturesque boathouses that dotted the shoreline in front of the great summer estates. (Courtesy of the Grosse Pointe Historical Society.)

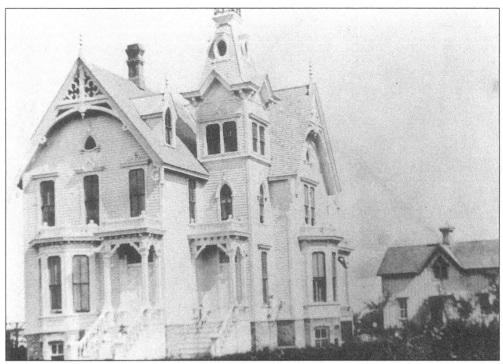

GINGERBREAD DREAM, C. 1880. This Queen Ann mansion and barn belonging to the Dingeman family was located at Bishop Road and Jefferson Avenue in Grosse Pointe Park. Bishop Road received its name due to the fact that the Right Reverend Casper Henry Borgess, Roman Catholic Bishop of Detroit, summered at a country retreat on the property. This land encompassed portions of the Simon Poupard and Joseph Saucier (n. Socia) farms. (Courtesy of the Burton Historical Collection of the Detroit Public Library.)

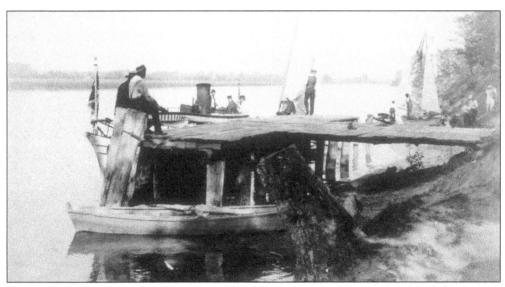

FUN IN THE WAVES, C. 1880. Lake St. Clair kept summer residents engaged all day long in a variety of fun activities, including fishing, sailing, rowing, bathing and simply gazing at the dancing waves. (Courtesy of the Grosse Pointe Historical Society.)

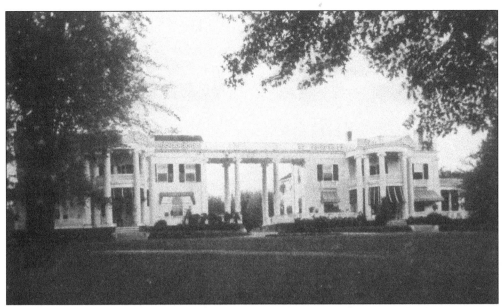

DOUBLE VISION, C. 1890. These imposing, antebellum twin-houses were built as a summer retreat for Alexander Lewis and his family of 13 children, on Lake Shore Road and Lewiston Road in Grosse Pointe Farms. Lewis was elected mayor of Detroit in 1875 on the "Law and Order" ticket which favored closing saloons on the Sabbath. Though one of these houses was torn down, the adjoining St. Paul's Roman Catholic Parish purchased the other in 1959 from Mr. and Mrs. Burns Henry Jr. Today the extensively remodeled home serves as the Parish House for St. Paul's Roman Catholic Church. (Courtesy of the Jay F. Hunter Collection/Grosse Pointe Historical Society.)

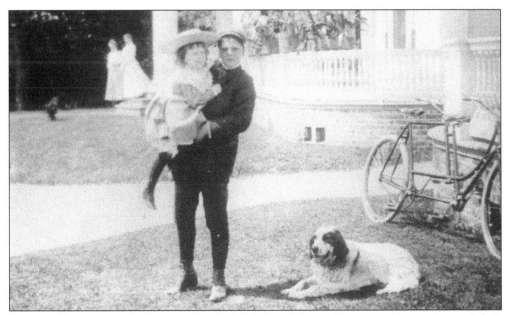

SUMMER FUN, C. 1910. Cousins Elizabeth Muir and Lewis Carpenter play in front of their grandfather Alexander Lewis's summer home. (Courtesy of the Jay F. Hunter Collection/Grosse Pointe Historical Society.)

33

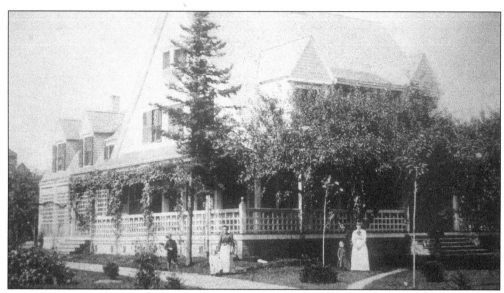

COMFORTABLE COTTAGE, C. 1890. Grocery wholesaler/banker/shipping magnate John Vallee Moran purchased this farm, at Lake Shore Road near Merriweather Road in Grosse Pointe Farms, in 1890 so that his family of ten could frolic in the summer sunshine. Meal time at the Moran's boasted the bountiful harvest from the gardens and arbors that surrounded this house. The children also enjoyed the fruit from the old French pear, cherry, and apple trees that bloomed in the property's orchards. When the family returned to Detroit in the winter, their caretaker would make the trip from Grosse Pointe in a horse-drawn carriage to deliver fresh milk, cream, and eggs weekly. (Courtesy of the Grosse Pointe Historical Society.)

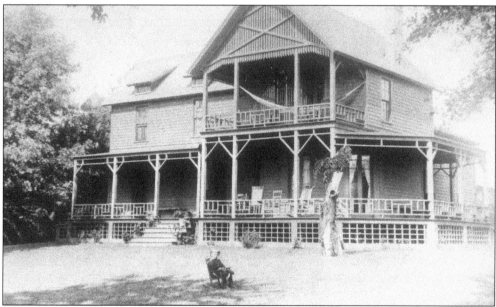

WEEANNE, C. 1889. Tiny Anna Davenport Russel, daughter of prominent Detroit railway attorney Henry Russel, sits on the rambling lakeside lawn of the family cottage, named in her honor, on Lake Shore Road near the present site of St. Paul's Roman Catholic Church in Grosse Pointe Farms. (Courtesy of the Jay F. Hunter Collection/Grosse Pointe Historical Society.)

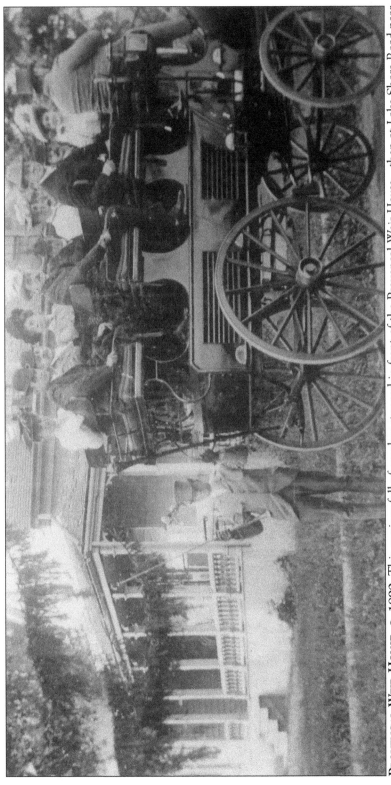

PROVENCAL-WEIR HOUSE, c. 1890. This carriage full of revelers stopped in front of the Provencal-Weir House—then at Lake Shore Road near Provencal Road in Grosse Pointe Farms. Recognized as the oldest remaining home in Grosse Pointe Farms, it was built about 1823 by Indian agent/farmer Pierre Provencal and his wife Euphemia St. Aubin. In the wake of Detroit's numerous epidemics, the Provencals opened their home to 24 orphans and raised them to adulthood, along with their daughter Catherine. They also invited Roman-Catholic missionaries, including Father Pierre Gabriel Richard, to celebrate Holy Mass and hear confessions in their parlor. The farm was later deeded to Catherine and her husband, Judge James D. Weir of Detroit, who used it as a summer home. In 1914, the house was moved to its present site on Kercheval Avenue at Lakeview Avenue in Grosse Pointe Farms. It is currently owned and operated by the Grosse Pointe Historical Society. (Courtesy of the Burton Historical Collection of the Detroit Public Library.)

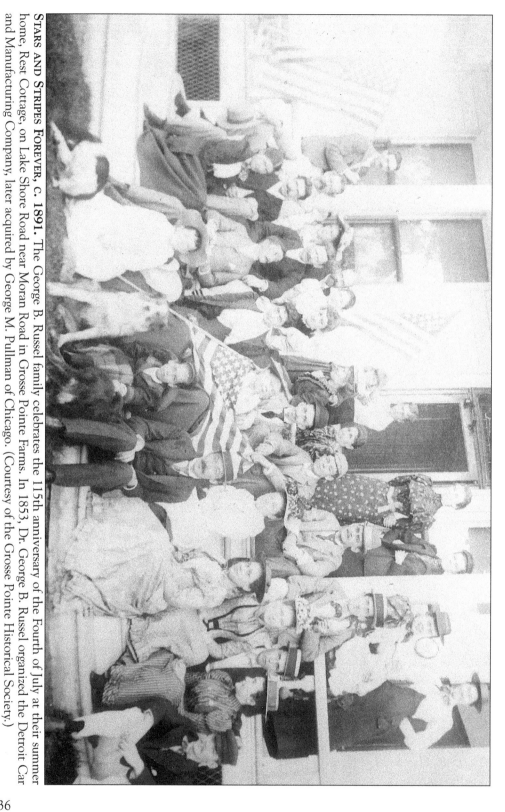

STARS AND STRIPES FOREVER, C. 1891. The George B. Russel family celebrates the 115th anniversary of the Fourth of July at their summer home, Rest Cottage, on Lake Shore Road near Moran Road in Grosse Pointe Farms. In 1853, Dr. George B. Russel organized the Detroit Car and Manufacturing Company, later acquired by George M. Pullman of Chicago. (Courtesy of the Grosse Pointe Historical Society.)

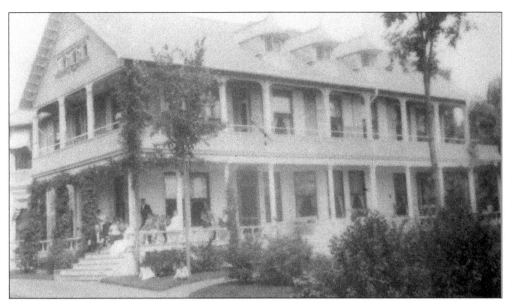

REST COTTAGE, C. 1891. From April through November, the George B. Russel family enjoyed all the social and sporting pleasures the Pointes had to offer. Their home, Rest Cottage, was built by leading Detroit physician Dr. Morse Stewart. The Russel family acquired and renovated this house in 1891. (Courtesy of the Grosse Pointe Historical Society.)

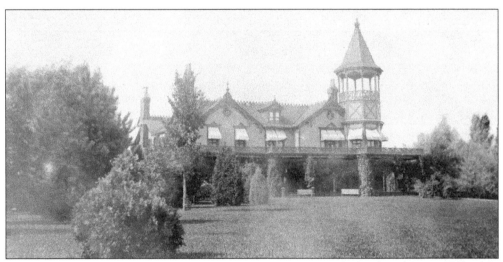

BELLEVUE, C. 1890. Born into one of Detroit's pioneer French families, lawyer William B. Moran summered in the Pointes at Bellevue, located near Lake Shore Road and Whitcomb Drive in Grosse Pointe Farms. In a project that newspapers dubbed "Moran's Folly," Moran and his cousin Charles Moran reclaimed the ground under the *Grand Marais*, or Great Marsh. This area included land below Jefferson Avenue from the old Lighthouse Road, now known as Alter Road, to Grand Marais Road in Grosse Pointe Park. In 1874, their Windmill Pointe Development Company purchased seemingly useless parcels of submerged land, then pushed a bill through the state legislature empowering the Wayne County Drain Commissioners to build dikes and ditches. After pumping the water out, and creating a landfill with rubbish from Detroit and dirt dredged from the bottom of the Detroit River. They owned 900 acres of what is now prime Grosse Pointe Park real estate. (Courtesy of the Grosse Pointe Historical Society.)

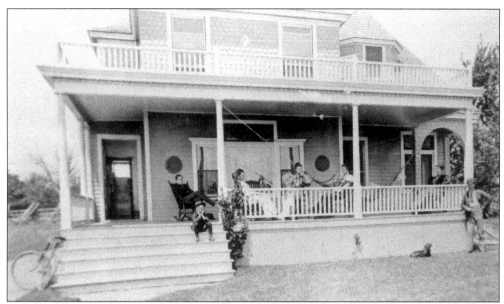

WATCHING THE WORLD GO BY, C. 1895. From their comfortable perch on the front porch of the Metcalf house on Lake Shore Road near Lochmoor Boulevard in Grosse Pointe Shores, Mr. and Mrs. Dudley Woodbridge, Maude Metcalf, Mable Metcalf, Mr. and Mrs. Charles H. Metcalf, Woodbridge Metcalf, and a dog named Smut, watch the world go by. (Courtesy of the Grosse Pointe Historical Society.)

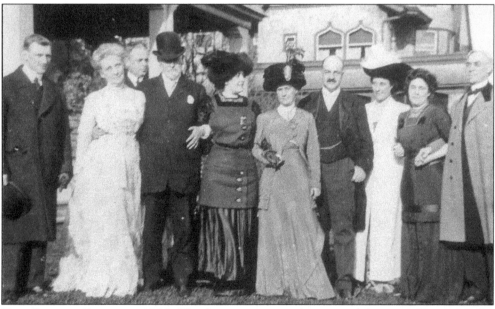

THE CABBAGE PATCH, C. 1900. This happy group may be some of the many Detroiters who rented houses along Berkshire Place in Grosse Pointe Farms. Originally developed by William A.M. McGraw and J. Hill Whiting, the area was expanded in 1903 by Hugo Scherer and Fred Wadsworth. Due to the relatively close proximity of the houses, the neighborhood was nicknamed "The Cabbage Patch" by social mavin Mrs. Henry B. Joy, after the quaint cottages in the children's book *Mrs. Wiggs of the Cabbage Patch*. (Courtesy of the Grosse Pointe Historical Society.)

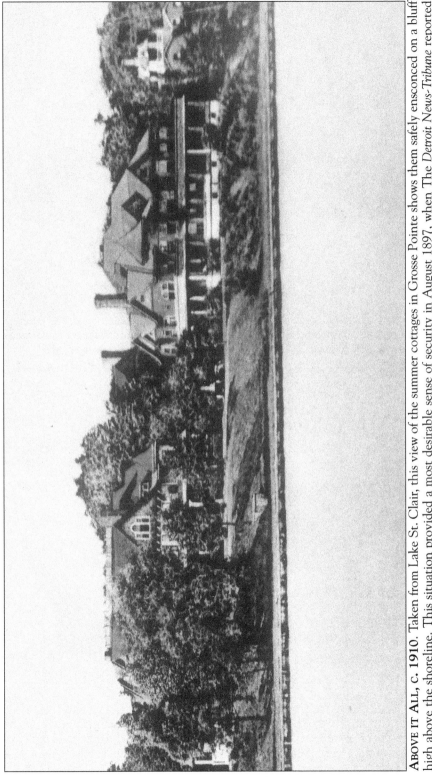

ABOVE IT ALL, C. 1910. Taken from Lake St. Clair, this view of the summer cottages in Grosse Pointe shows them safely ensconced on a bluff high above the shoreline. This situation provided a most desirable sense of security in August 1897, when The *Detroit News-Tribune* reported sightings of "sea serpents" on Lake St. Clair and at other Great Lakes resorts, from Canada to Minnesota. Particularly alarming was an account in which a horse, hitched near the shore in Grosse Pointe, vanished after a fierce battle with a sea serpent. Another article described a creature captured in the Detroit River as having a mouth "as large as a coal stove" and traveling at "the speed of a trolley car after midnight." (Courtesy of the Grosse Pointe Historical Society.)

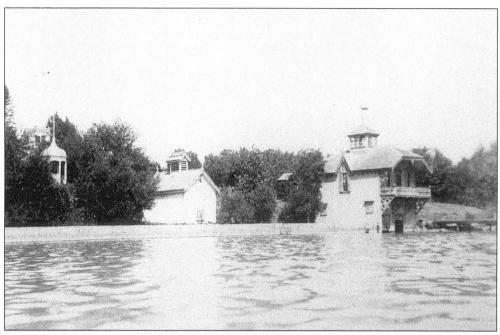

SHOWY SHORELINE, C. 1900. Gingerbread boathouses dotted the shoreline of Lake St. Clair during the late 19th and early 20th centuries. (Courtesy of the Grosse Pointe Historical Society.)

BEAUTIFUL BEACH CHAIR, 1880. These summer visitors relax on a Victorian settee at the beach near the home of pharmaceutical supply merchant Theodore H. Hinchman on the Lake Shore Road property of the Grosse Pointe War Memorial in Grosse Pointe Farms. (Courtesy of the Grosse Pointe Historical Society.)

HINCHMAN COTTAGE, C. 1900. Detroit pharmaceutical supply wholesaler, fire commissioner, and Michigan State Senator Theodore H. Hinchman became one of the founders of the Pointe's summer colony when he built this "cottage" in 1862 on property now occupied by the Grosse Pointe War Memorial, on Lake Shore Road, in Grosse Pointe Farms. (Courtesy of the H. Livingstone Bogle Collection.)

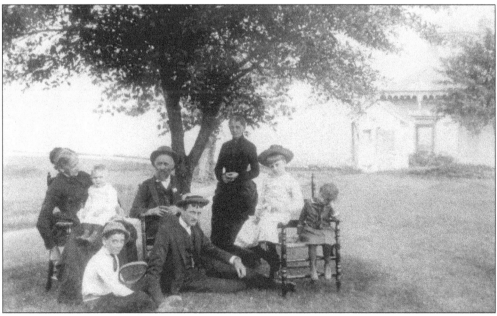

SUMMER REPOSE, C. 1900. The family of Theodore Hinchman gather near the boathouse at their Grosse Pointe Farms "cottage." Son Theodore H. Hinchman Jr., an engineer, was treasurer of Detroit's Smith, Hinchman, and Grylls, now the SmithGroup Inc., which is the oldest continuously operating architectural firm in the United States. (Courtesy of The Grosse Pointe Historical Society.)

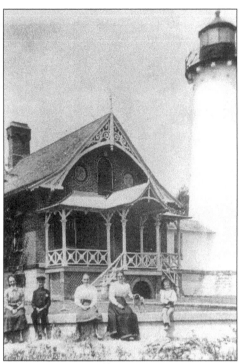

GUIDING LIGHT, C. 1900. The beams of the Windmill Pointe Lighthouse, built along with a Keeper's Cottage in 1875 at the mouth of Fox Creek, near Alter Road, on the Grosse Pointe Park/Detroit boarder, guided sailors entering the Detroit River or Lake St. Clair. The people in this photograph may be the family of Lighthouse Keeper Nathan Kennedy. This tower replaced an earlier lighthouse, which dated to 1838. At its maximum intensity in 1929, the lighthouse generated 12,000 candlepower for its fixed white signals. In 1930, it was replaced by an automated signal. (Courtesy of the Grosse Pointe Historical Society.)

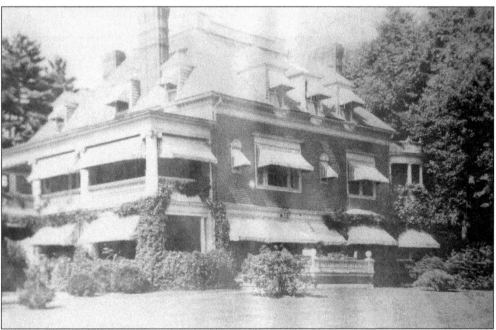

DRYBROOK, C. 1910. This rambling colonial-revival summer "cottage" was built in 1888 for railroad car magnate William C. McMillan of the Michigan Peninsular Car Company. The home was originally situated on Lake Shore Road near Newberry Place in Grosse Pointe Farms. In 1914, the house was split and moved on horse-drawn wooden rollers to separate sites on Moran Road in Grosse Pointe Farms and University Place near Jefferson Avenue in the City of Grosse Pointe. (Courtesy of the Grosse Pointe Historical Society.)

42

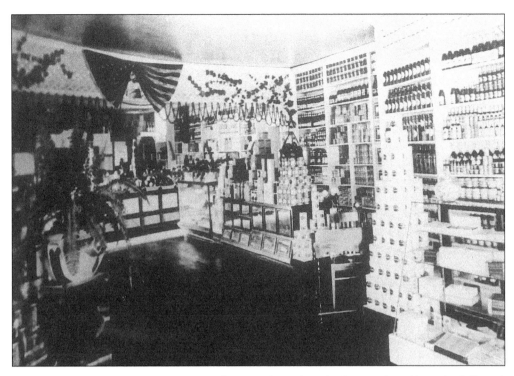

UPSCALE EDIBLES, C. 1916. Many small stores thrived in the Pointes but Chas. A. Gilligan's Edibles Emporium, on Lake Shore Road near Elmsleigh in the City of Grosse Pointe, catered to an elite, special-order clientele. (Courtesy of the Grosse Pointe Historical Society.)

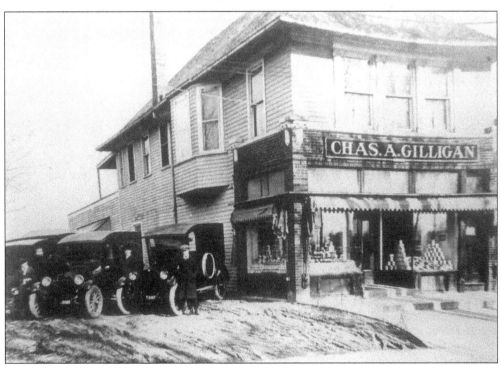

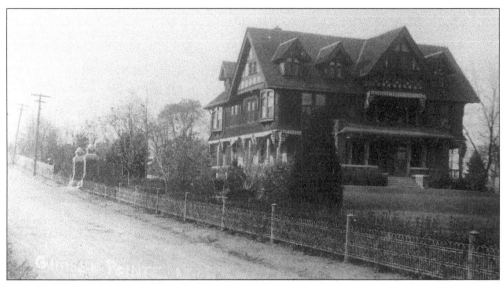

SCHMIDT HOUSE, C. 1915. The Carl E. Schmidt home was built in 1909 on Lake Shore Road and Kerby Road in Grosse Pointe Farms. Schmidt inherited his father's Detroit leather tannery, known as Trapper's Alley. The business prospered during the Civil War as a major supplier of leather goods to Union forces. The house was heavily remodeled in the 1920s and still stands on its original site. (Courtesy of the H. Livingstone Bogle Collection.)

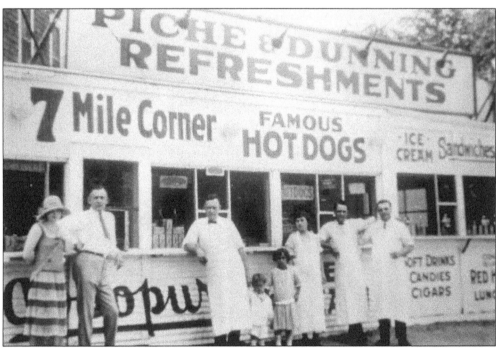

HOT DOG! C. 1920. One of the Grosse Pointe area's favorite fast food joints, Piche & Dunning Refreshments, located on the corner of Moross (Seven Mile) Road and Mack Avenue in Grosse Pointe Farms, was famous for its homemade mustard relish. Pictured here, from left to right, are an unknown customer, George Dunning, Warren Piche Jr., Verna Piche, Lydia Piche, Warren Piche, and an unidentified employee. (Courtesy of the Russel "Forest" Piche Collection.)

Four

EVERYBODY'S
DOING IT NOW

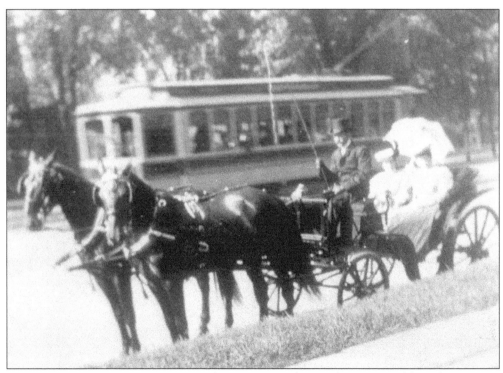

A MATTER OF PREFERENCE, C. 1904. These summer colonists chose to travel from their Detroit home by carriage, making the journey to Grosse Pointe in nearly two hours. However, by 1890, those who required a less leisurely pace could make the trip in approximately 28 minutes via streetcar. (Courtesy of the Grosse Pointe Historical Society.)

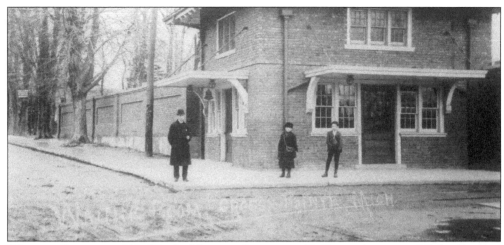

WAITING ROOM, C. 1902. This building, on the corner of Jefferson Avenue and Fisher Road in the City of Grosse Pointe, sheltered commuters as they waited for the streetcars. The opening of the East Detroit and Grosse Pointe Railway in 1888 greatly contributed to Grosse Pointe's evolution into a year-round suburb of Detroit. The original lines ran along E. Jefferson Avenue in Detroit to Cadillac to Mack to St. Clair Avenue, then back to the terminus at Jefferson Avenue and Cadieux Road in the City of Grosse Pointe. In 1891 a second line, the Jefferson Avenue Railway, was added, running from Waterworks Park, along E. Jefferson Avenue in Detroit to Fisher Road in the City of Grosse Pointe. By 1898, the Detroit, Lake Shore, and Mt. Clemens Railway, known as the Interurban, ran down Grosse Pointe Boulevard, a right-of-way created to preserve estate owners' views of the lake. It ended at Weir Lane, now Provencal Road, in Grosse Pointe Farms. (Courtesy of the Grosse Pointe Historical Society.)

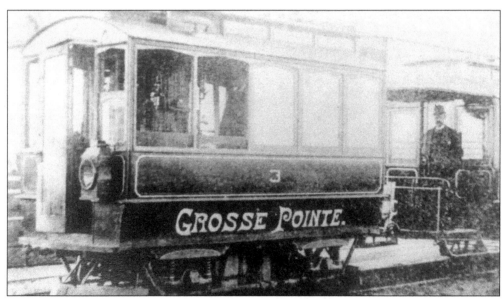

ROUGH RIDE, C. 1893. Traveling to the Pointes via rutted tracks in a steam-powered Interurban car, like this Healy Motors model, was reportedly not for the faint-of-heart. Recalled one passenger in 1894, "A ride over the Mack Avenue line and its extension to Grosse Pointe will cure dyspepsia, if violent exercise is a specific [cure] for that disease." Even the cars, he sniffed, "resemble the picture of discomfort." (Courtesy of the Grosse Pointe Historical Society.)

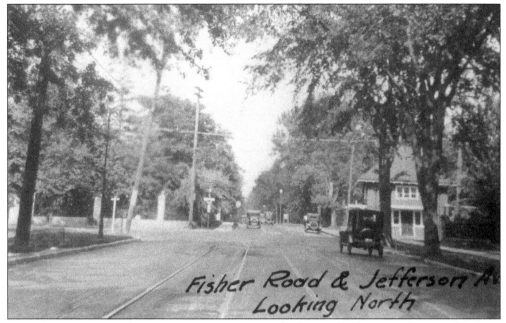

The handwritten text on the image reads:

*Fisher Road & Jefferson A...
Looking North*

MAKING TRACKS, C. 1920. Interurban streetcar tracks share Lake Shore Road near Fisher Road in Grosse Pointe Farms, with the automobiles that would eventually render them obsolete. (Courtesy of the Ignatius Backman Family Collection/Grosse Pointe Historical Society.)

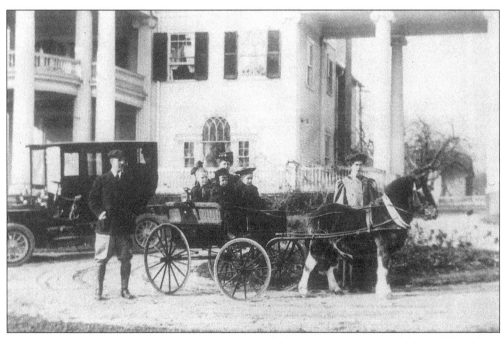

PONY POWER VS. HORSEPOWER, C. 1905. Though the family car was readily available, these children preferred to ride in their pony cart. Pictured in front of the Alexander Lewis House on Lake Shore Road and Lewiston Road in Grosse Pointe Farms are, from left to right, Howie Muir, Betty Muir, William K. Muir, Marian Muir, and Marjorie Muir. (Courtesy of the Sally Cudlip Archives/Jay F. Hunter Collection.)

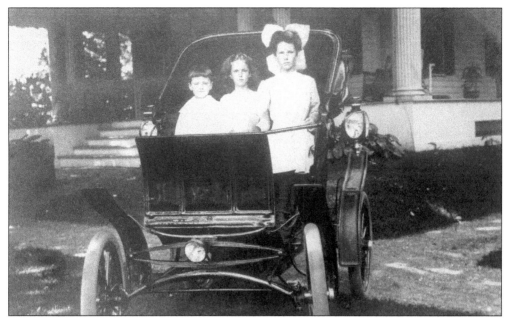

IN THE DRIVER'S SEAT, C. 1910. Miss Marion Scherer, daughter of prosperous wholesaler Hugo Scherer, takes the wheel in front of her family's pillared mansion on Lake Shore Road and Moran Road in Grosse Pointe Farms. (Courtesy of the H. Livingstone Bogle Collection.)

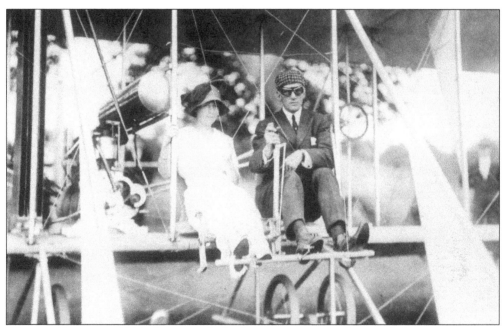

WRIGHT STUFF, C. 1911. In gratitude for his investment in their early business ventures, Wilbur and Orville Wright sent Pointer Russell A. Alger Jr. a #6 biplane in 1911. Beth Loomis and Frank Coffyn lift off in the craft from the Country Club of Detroit golf course, near the present site of Grosse Pointe South High School, at Fisher Road and Grosse Pointe Boulevard in Grosse Pointe Farms. Their high-flying joyride, which cost $25, took them 400 feet into the air. (Courtesy of the Grosse Pointe Historical Society/Nancy Dodge Heenan.)

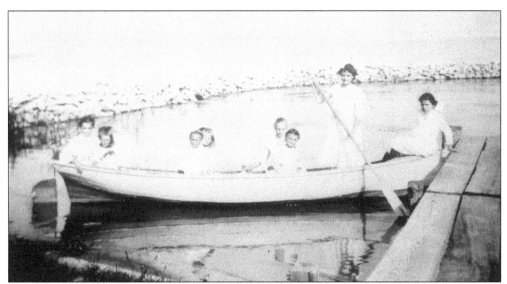

ROW YOUR BOAT, C. 1912–1917. Children enjoy the simple pleasures of a summer's day in front of the Academy of the Sacred Heart on Lake Shore Road and Moran Road in Grosse Pointe Farms. (Courtesy of The Grosse Pointe Academy Collection.)

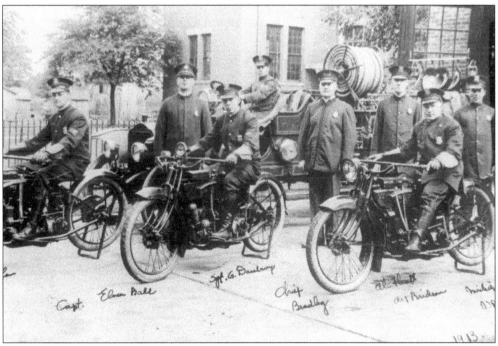

FARMS POLICE AND FIRE, 1913. Proud members of the Grosse Pointe Farms Fire Department, founded in 1895, join Farms police officers in front of the Village Hall. This brick structure replaced the old frame Protestant church which was moved in 1894 to a site on Kerby Road between Kercheval Avenue and Grosse Pointe Boulevard in Grosse Pointe Farms. It served as the Village Hall until the present structure was completed in 1912. Seen on the left is the third home of Kerby Elementary School, built in 1905. (Courtesy of the Ignatius Backman Family Collection/Grosse Pointe Farms.)

49

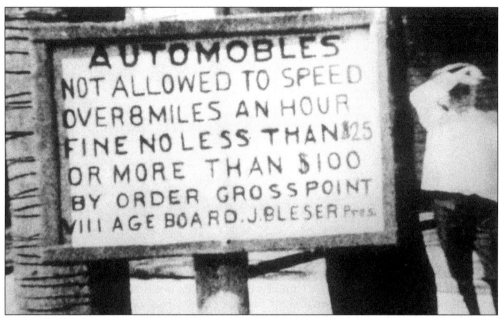

SIGN OF THE TIMES, C. 1910. In response to area auto owners' habit of using Grosse Pointe streets as test tracks, city fathers took action to ensure the safety of the citizenry. (Courtesy of the Burton Historical Collection of the Detroit Public Library.)

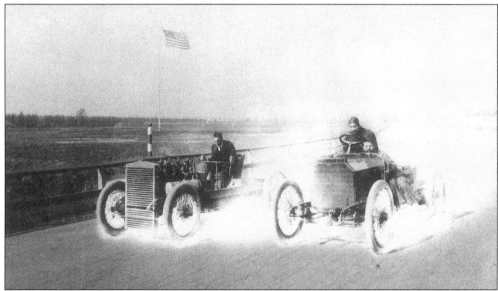

START YOUR ENGINES! C. 1901. Henry Ford, on the right, and Alexander Winton, speed toward fame and fortune in the 999 race car at the old Grosse Pointe Race Track. The team won the 10-mile race in 13 minutes, 23.4 seconds. Winton, on the running board, served as a "human carburetor." Completed in 1895, on land owned by Detroit Driving Club President Daniel J. Campau Jr., the track was situated on E. Jefferson Avenue at Lenox in what was then the Village of Fairview in Grosse Pointe Township. Though originally a horse-racing track, the sides were banked in 1901 to accommodate cars. Auto racing at the track ceased in 1905. (Courtesy of The Henry Ford Museum/Greenfield Village Archives.)

DAD'S CAR, C. 1924. Brothers John and Bruce Bockstanz check out their father's Buick sedan, which is parked near their home on Hollywood Road in Grosse Pointe Woods. Because there were only four houses on their street, the stores on Mack Avenue can be seen in the background, including the Hoop-De-Do roadhouse. (Courtesy of Bruce Bockstanz.)

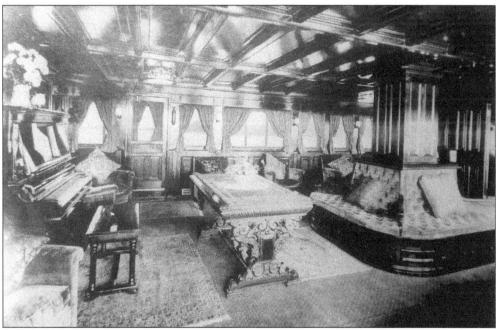

PALACE OF THE WAVES, C. 1913. Horace and John Dodge spent a fair portion of their early automotive fortune setting sail on a series of yachts like the Nokomis, named for the mother of the legendary Hiawatha, whose elegantly appointed salon is pictured here. The Dodge brothers, attended by a crew of 30, used the steam yacht for business and pleasure cruises for four years until it was requisitioned by the United States Navy for service in World War I. (Courtesy of the Grosse Pointe Historical Society.)

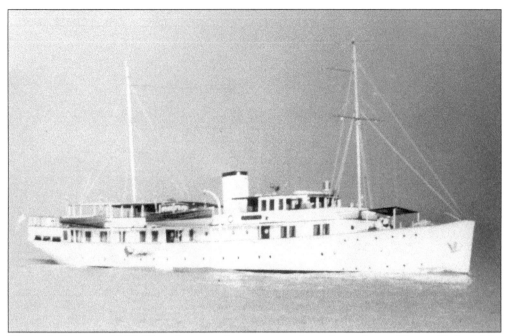

WORLD'S BEST, C. 1925. Though it was the crowning glory of auto baron Horace Dodge's life-long passion for yachts, the 258-foot *Delphine II* was launched on April 2, 1921, three months after his death. At the time, it was the largest luxury craft in the world. The floating palace was moored behind the family's Lake Shore Road home, Rose Terrace, in Grosse Pointe Farms. Because of its tremendous tonnage, an unusually deep channel was cut into the bed of Lake St. Clair to accommodate it. After changing hands several times and serving in World War II, the ship is currently in Europe, being restored by new owners. (Courtesy of the Grosse Pointe Club.)

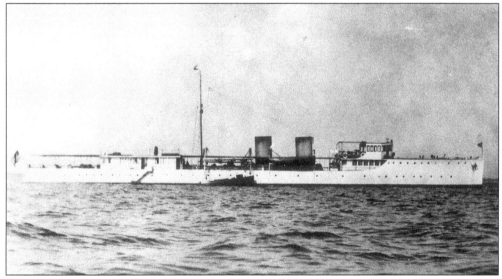

AT THE MOORINGS, C. 1925. *The Winchester*—one of several yachts owned by Russell A. Alger Jr., vice president of the Packard Motor Car Company—was moored, along with a genuine gondola, to Venetian poles behind his home, The Moorings, at Lake Shore Road and Elm Court in Grosse Pointe Farms. (Courtesy of the Grosse Pointe War Memorial Association Collection.)

Five

HIGH SOCIETY

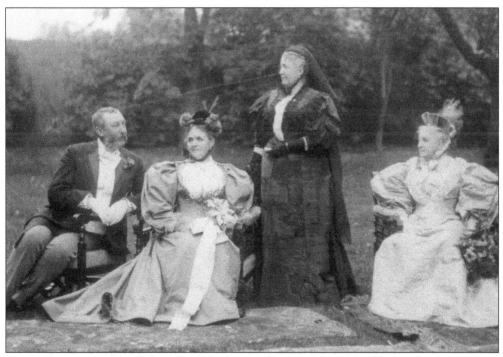

VERY VICTORIAN, 1895. Seated in Victorian splendor are street railway and transportation magnate George Hendrie and several members of his family. Known for the shrewdness and tact of a true son of Scotland, Mr. Hendrie married Sara Trowbridge, daughter of one of Detroit's first families. He summered in the Pointes at Willow Bank, near Lake Shore Road and Moran Road. (Courtesy of the Sally Cudlip Archives/Jay F. Hunter Collection.)

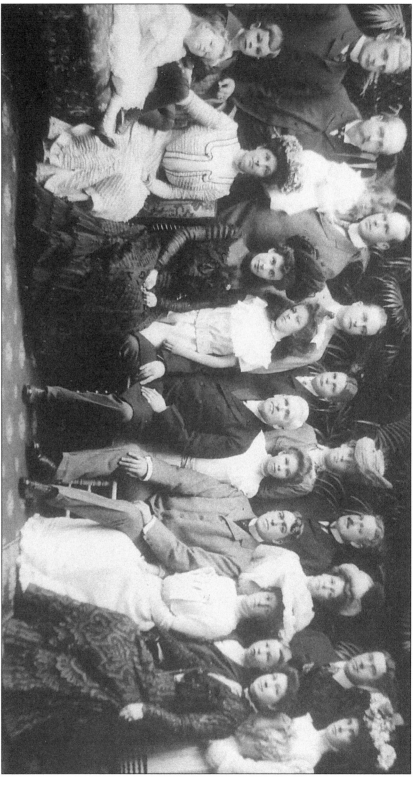

A WEALTH OF FAMILY, C. 1900. For much of the area's summer colony, Detroit's Social Register read like a family phone book. These Pointe residents are the progeny of former Detroit Mayor Alexander Lewis (center, front row). Pictured, from left to right, are: (front row) Elizabeth I. Muir, John D. Currie, Josephine L. Carpenter, Margie C. Lewis, Gwendolyn Currie, Alexander Lewis, Gladys V. McMillan, Alexander I. Lewis, Marian L. Muir, James McMillan II, and Nannie C. Lewis; (back row) Clarence Carpenter, Edgar L. Lewis, Marjorie H. Muir, William H. Muir, Henry B. Lewis, Lewis G. Carpenter, Julie L. McMillan, Cameron Currie, Harriet L. Currie, James H. McMillan, and Bertha P. Lewis.(Courtesy of the Sally Cudlip Archives.)

BOUNTIFUL BARONESS, C. 1900. The Baroness Maud Ledyard VonKettler— a descendant of Michigan's first governor, Lewis B. Cass— summered at her family's Grosse Pointe Farms estate, Cloverleigh, before marriage took her to the far reaches of the world. Following the murder of her diplomat husband Baron Clement VonKettler during China's Boxer Rebellion in 1900, Maud traveled to Germany. There she was appointed the arbitrator of social manners to the royal court of Kaiser Wilhelm II. Upon her return to the Pointes, she served on the Board of Directors of the Mutual Aid Society/Neighborhood Club, eventually becoming a volunteer nurse. In 1919, she was instrumental in purchasing and refurbishing the cottage on Muir Road in Grosse Pointe Farms that eventually evolved into the community's first full-service healthcare facility, Cottage Hospital. She later moved to Connecticut where she lived until her death in 1960. (Courtesy of the Cottage Hospital Collection.)

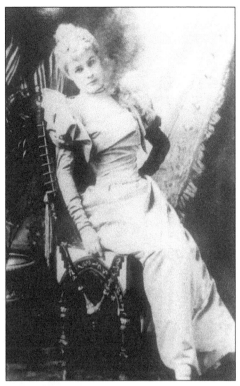

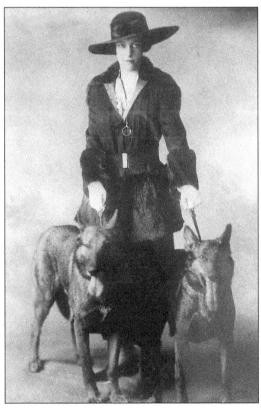

GLAMOUR PERSONIFIED, C. 1920. Grosse Pointe Farms resident Gwendolyn Currie Seyburn became the Countess Cyril Tolstoi after marrying a distant relative of the famed Russian author. The couple lived in a gracious home on Lewiston Road near Ridge Road; the property was once part of her family's summer retreat. (Courtesy of the Jay F. Hunter Collection.)

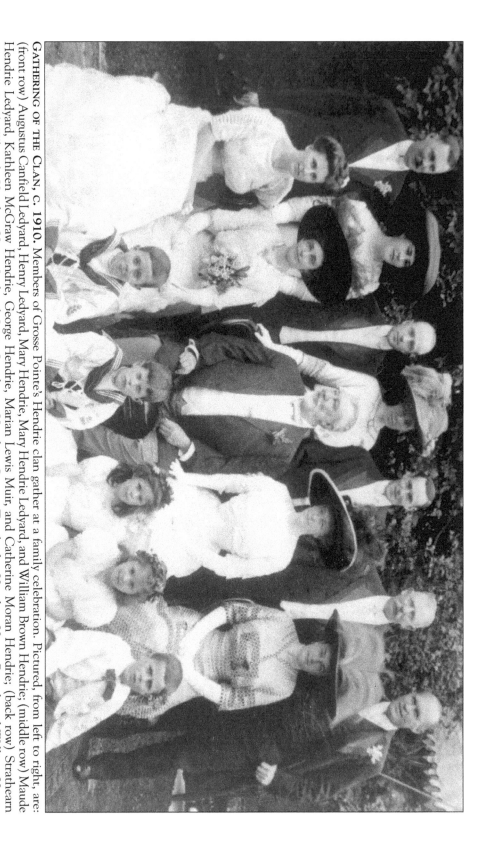

GATHERING OF THE CLAN, C. 1910. Members of Grosse Pointe's Hendrie clan gather at a family celebration. Pictured, from left to right, are: (front row) Augustus Canfield Ledyard, Henry Ledyard, Mary Hendrie, Mary Hendrie Ledyard, and William Brown Hendrie; (middle row) Maude Hendrie Ledyard, Kathleen McGraw Hendrie, George Hendrie, Marian Lewis Muir, and Catherine Moran Hendrie; (back row) Strathearn Hendrie, Sarah Whipple Hendrie, Henry Ledyard, Jessie Strathearn Hendrie, George Trowbridge Hendrie, Henry Russel, and William Howie Muir. (Courtesy of the Jay F. Hunter Collection/Grosse Pointe Historical Society.)

HARMONIOUS GROUP, C. 1915. The choir of St. Paul's Roman Catholic Church, on Lake Shore Road at Lewiston Road in Grosse Pointe Farms, celebrates the dedication of its new organ with Father Alonzo H.B. Nacy, pastor. (Courtesy of the Mr. and Mrs. Albert E. Beaupre Family Collection.)

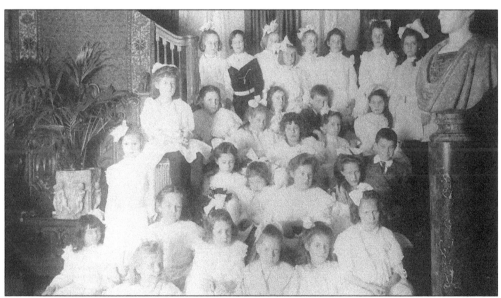

PETITE PARTY, C. 1910. The guest list of Marion Scherer's party, whose family's home was at Lake Shore Road and Moran Road in Grosse Pointe Farms, read like a who's who of the Detroit and Grosse Pointe's younger set. Revelers included, from left to right, (front row) Margaret Longyear and Katherine Remick; (second row) Elizabeth Hamilton, Elizabeth Dwyer, Fay Alger, Elizabeth Muir, Barbara Lobenstein, and Helen Hunt; (third row) Charlotte Skinner, Marie Louise Palms, Marjorie Muir, Katherine Demme, Katherine Andrus, and Jack Currie; (fourth row) Margaret Eaton, Marjorie Stearns, Christina van Husen, Ilene Parker, David Whitney, Doris McMillan, and Cora Peck; (back row) Margaret Post, Allan Stearns, Marion Joy, Helen Joy, Elizabeth Russel, Josephine Alger, Marion Scherer, and Josephine Palms. (Courtesy of the H. Livingstone Bogle Collection.)

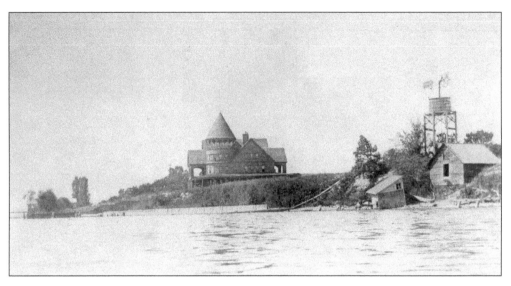

A SOCIAL CENTER, C. 1902. Answering a need for a social center in the Pointes, prominent citizens organized the Grosse Pointe Club in 1884 and built this clubhouse, at Fisher Road and Jefferson Avenue in the City of Grosse Pointe, in 1886. The "elephantine" shingled structure boasted a 16-foot wide veranda, which ran 322 feet along the lakeside of the building. The inaccessibility of the Pointes forced the Club to close in 1888. The building then housed the privately owned Grosse Pointe Casino. Drawn together by the love of golf, prominent Detroiters incorporated the Country Club of Detroit in 1897 and soon leased this building as its first clubhouse. They then leased 125 acres of land, reaching northward to Ridge Road, for their first golf course. The property also offered docks for yachts and plenty of room for riding and baseball. (Courtesy of the Sally Cudlip Archives.)

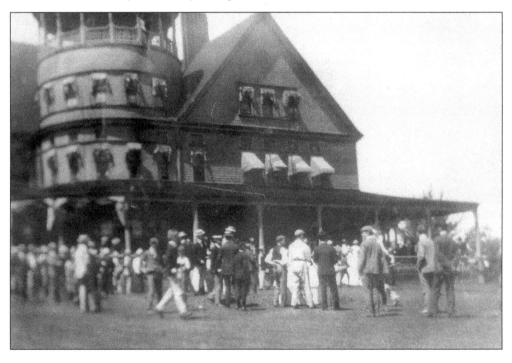

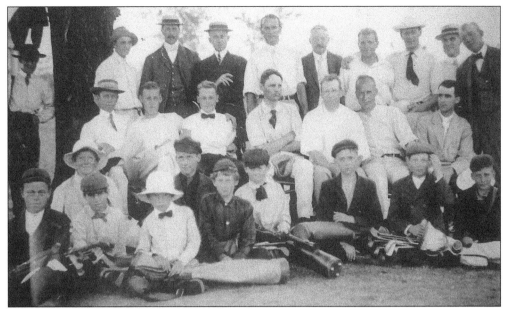

CADDIES, C. 1901. Local boys could make a pretty penny caddying for golfers at the Country Club of Detroit. Today, the C.C.D. employs approximately 250 caddies per season and allows those who work for two years or more to compete for the Evans Scholars Foundation Scholarship, offering housing and tuition grants at 14 universities. (Courtesy of the Sally Cudlip Archives.)

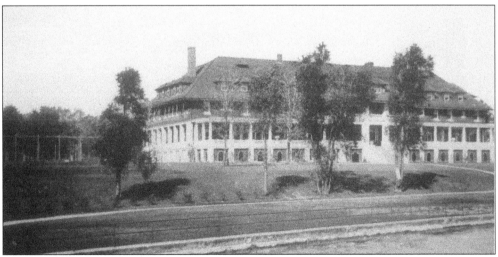

COUNTRY CLUBHOUSE II, C. 1907. Renowned industrial architect Albert Kahn designed the four-story brick clubhouse for the Country Club of Detroit, which opened in May 1907 on Lake Shore Road near Fisher Road in the City of Grosse Pointe. This building replaced the original 1897 clubhouse, which had fallen into disrepair. Among the advantages the new facility offered members were 20 bedrooms and a similar number of guest rooms, a large garage for automobiles, five tennis courts, a golf course and a long, lakefront glass-enclosed veranda. When the C.C.D. moved inland, the property was sold to Mrs. Horace Dodge, who incorporated it into her neighboring Rose Terrace estate. The clubhouse was demolished in 1928. (Courtesy of the Grosse Pointe Historical Society.)

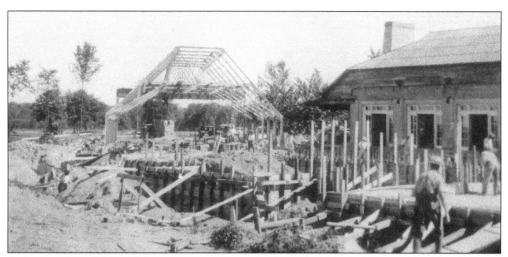

COUNTRY CLUB MOVES INLAND, C. 1922. Increased membership and encroaching development forced the Country Club of Detroit golf course inland, to the northern portion of the Weir farm, on the northeast edge of Grosse Pointe Farms, in 1911. A portion of this property, known as the Provencal Road Subdivision, was sold to members so their homes could surround the greens. Harry Colt, a British golf architect, was hired to design the golf course, which opened in 1912. Albert Kahn created an old English-style clubhouse, shown here under construction. It was hailed as a "triumph" in country club design when it opened in 1923. But the joy was short-lived. The Club burned to the ground in 1925. (Courtesy of the Ignatius Backman Family Collection/Grosse Pointe Farms.)

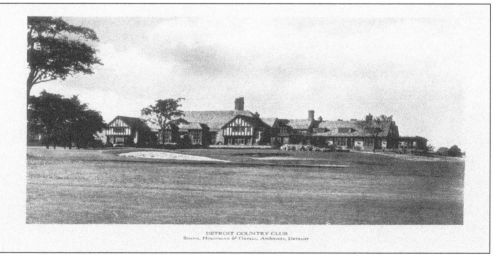

HOME AT LAST, C. 1926. Within days of the fire that destroyed the new inland home of the Country Club of Detroit, Smith, Hinchman, and Grylls of Detroit was selected to design a new facility on the site of the old. The Club's western boundary was broadened in 1926, by the purchase of the Hall estate, running along Moross Road from Kercheval Avenue to Mack Avenue in Grosse Pointe Farms. The edges of the 147-acre tract were later sold to members who built substantial homes along the edge of the golf course. The present clubhouse opened on April 23, 1927. Designed to reflect the aura of an English-country estate, the interior was graced by whimsical murals by Frederick Dana Marsh, a 75-foot indoor swimming pool, leaded-glass windows, and a two-story Great Hall. (Courtesy of the SmithGroup, Inc.)

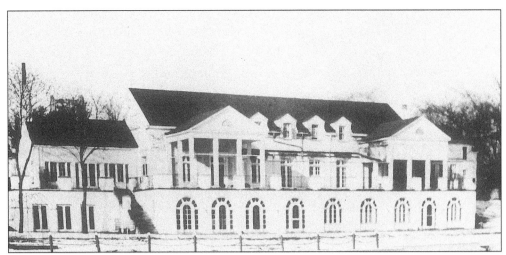

THE "LITTLE" CLUB, C. 1927. Though the Country Club of Detroit is known for its glorious golf facilities, yachting was the first love of many of its early members. When this sailing set lost their bid to purchase the lakeside clubhouse after the C.C.D. moved inland, they banded together at a neighboring shoreline venue and founded a new entity with an old name, The Grosse Pointe Club. This building, which still serves as the clubhouse, was built in 1927. Because of the facility's comparatively diminutive size ... and reputedly select membership, it is known locally as "The Little Club." (Courtesy of The Grosse Pointe Club.)

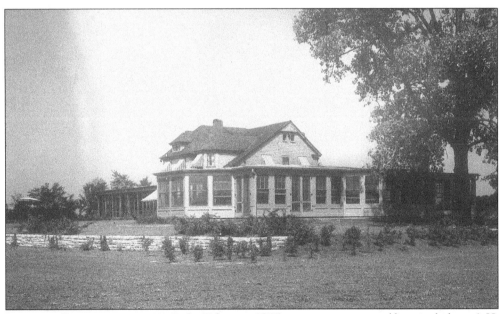

LINKS OF LOCHMOOR, C. 1917. In February 1917, prominent area golfers, including A.H. Buhl, Roy D. Chapin, Horace Dodge, John Dodge, Edsel Ford, and Oscar Webber, purchased 136 acres from farms belonging to the Beaufait, Van Antwerp, and D'Hondt families and began building the Lochmoor Club. After a day on the greens, designed by John S. Sweeney and Walter J. Travis, golfers gathered in this farmhouse on the property. The structure was destroyed by fire in February 1924. (Courtesy of the Detroit News Collection/Walter P. Reuther Library, Wayne State University.)

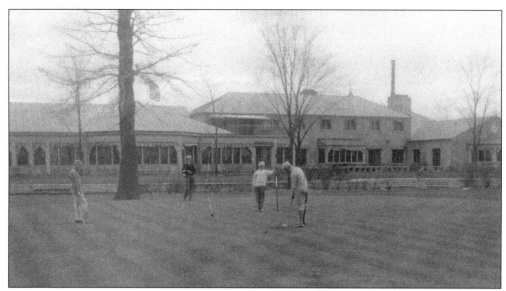

OUT OF THE ASHES, C. 1924. In November 1924, members of the Lochmoor Club opened a new clubhouse to replace the one destroyed by fire. After several expansions, this building was demolished and replaced by the present clubhouse in 1969. (Courtesy of the Detroit News Collection/Walter P. Reuther Library, Wayne State University.)

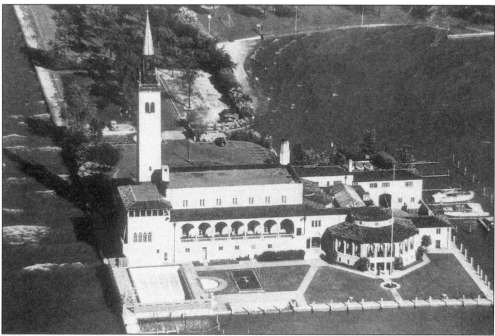

GROSSE POINTE YACHT CLUB, C. 1930. The newly built Grosse Pointe Yacht Club, a Venetian-Romanesque-Gothic structure boasting a 187-foot landmark tower, was built on landfill at Lake Shore Road and Vernier Road in Grosse Pointe Shores. The structure, designed by Boston architects Ralph Coolidge Henry and Henry P. Richmond, opened on July 4, 1929. Membership grew out of the old Grosse Pointe Ice Boating Club founded in 1910. (Courtesy of the Grosse Pointe Historical Society.)

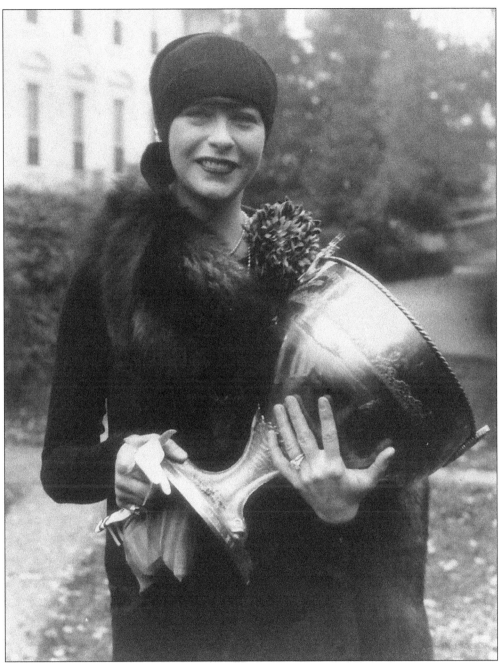

AUTO HEIRESS, C. 1925. Delphine Ione Dodge Baker Cromwell Godde, daughter of Auto Baron Horace Dodge, was born on February 11, 1899, in the simple surroundings of her Dodge grandparents' home. By the time of her death, at age 43, she had married three times, given birth to two daughters, was an accomplished pianist and an expert behind the wheel of both cars and boats. Most of all, she may be remembered as a shimmering figure, draped in couture gowns and the pearl necklace of Catherine the Great—a perfect icon for the fast fortunes fueled by the growth of Detroit's automotive industry. (Courtesy of The Dossin Great Lakes Museum.)

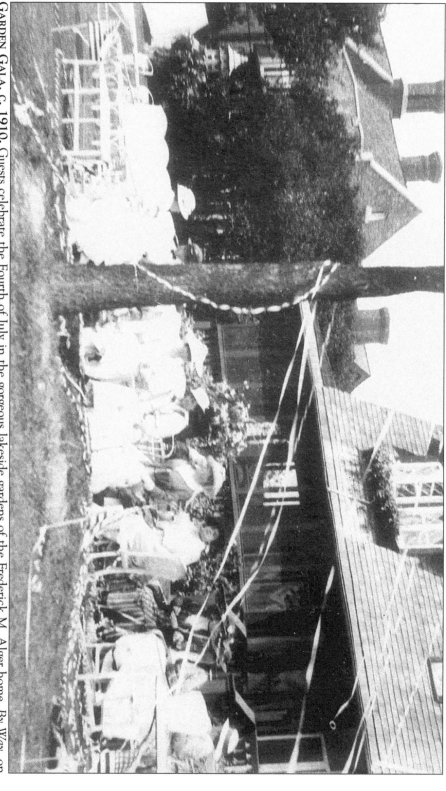

GARDEN GALA, c. 1910. Guests celebrate the Fourth of July in the gorgeous lakeside gardens of the Frederick M. Alger home, *By Way*, on Jefferson Avenue near Island Lane in the City of Grosse Pointe. Famed Arts and Craft architects William B. Stratton and Frank Baldwin designed the sprawling "cottage" style home and much of its furniture. Completed in 1908, the house was destroyed by fire in 1960. (Courtesy of the Sally Cudlip Archives.)

DARLING DEB, C. 1915. Miss Marion Scherer, daughter of Mr. and Mrs. Hugo Scherer of Grosse Pointe Farms, debuted at the Country Club of Detroit in December 1915. From the late-19th century until the 1970s, debutante parties were a fixture on the social calendars of Grosse Pointe's "Blue Book" families. Daughters were presented to society—and would-be husbands—at tasteful teas and elaborate dinner dances. In later years, Grosse Pointe debuts drew such top name entertainers as Frank Sinatra and Nat King Cole. (Courtesy of the H. Livingstone Bogle Collection.)

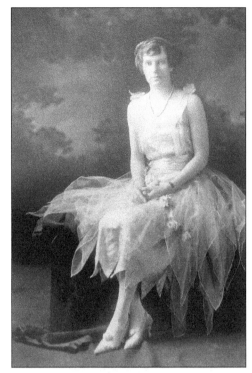

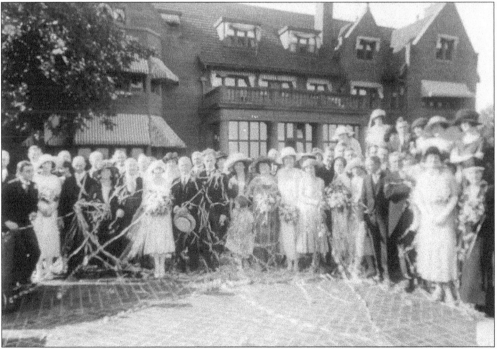

DODGE MERGER, 1921. Horace Dodge Jr. married Louise Knowlson on June 21, 1921. The couple is shown here at their reception at Horace and Anna Dodge's Rose Terrace estate on Lake Shore Road at Rose Terrace in Grosse Pointe Farms. (Courtesy of the Grosse Pointe Historical Society.)

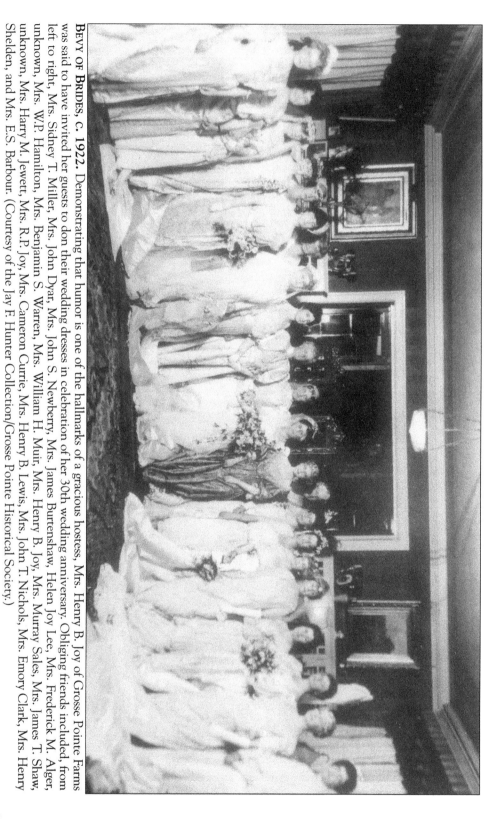

Bevy of Brides, c. 1922. Demonstrating that humor is one of the hallmarks of a gracious hostess, Mrs. Henry B. Joy of Grosse Pointe Farms was said to have invited her guests to don their wedding dresses in celebration of her 30th wedding anniversary. Obliging friends included, from left to right, Mrs. Sidney T. Miller, Mrs. John Dyar, Mrs. John S. Newberry, Mrs. James Burtenshaw, Helen Joy Lee, Mrs. Frederick M. Alger, unknown, Mrs. W.P. Hamilton, Mrs. Benjamin S. Warren, Mrs. William H. Muir, Mrs. Henry B. Joy, Mrs. Murray Sales, Mrs. James T. Shaw, unknown, Mrs. Harry M. Jewett, Mrs. R.P. Joy, Mrs. Cameron Currie, Mrs. Henry B. Lewis, Mrs. John T. Nichols, Mrs. Emory Clark, Mrs. Henry Shelden, and Mrs. E.S. Barbour. (Courtesy of the Jay F. Hunter Collection/Grosse Pointe Historical Society.)

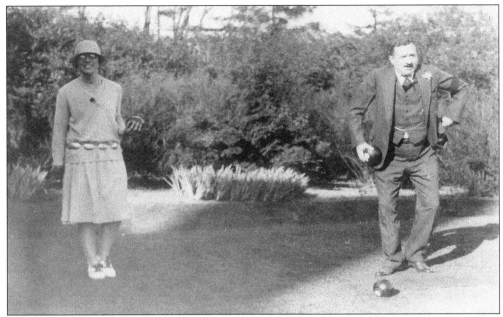

POPULAR PASTIMES, C. 1925. Marion Campbell and Percival Dodge join the Russell A. Alger Jr. family in lawn bowling and croquet on the grounds of their estate, The Moorings, on Lake Shore Road at Elm Court in Grosse Pointe Farms. The property is now a community center known as The Grosse Pointe War Memorial. (Courtesy of the Grosse Pointe War Memorial Association Collection.)

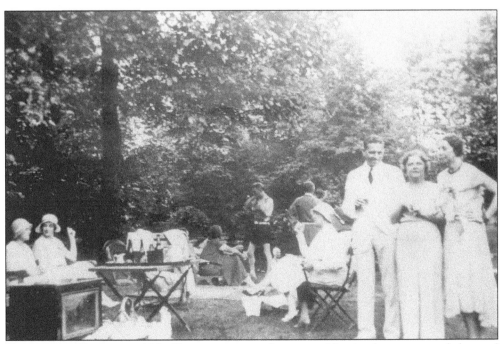

'ROUND THE POOL, C. 1929. Guests enjoy an afternoon of fun in the sun around the pool at the home of distillery heir Hiram Walker Jr. on Provencal Road in Grosse Pointe Farms. (Courtesy of the Grosse Pointe Historical Society.)

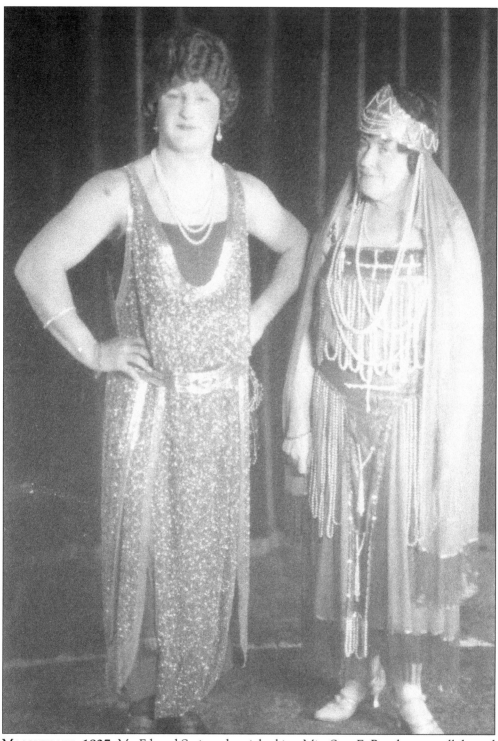

MASQUERADE, 1927. Mr. Edward Stair and social arbiter Miss Sara E. Burnham are all dressed up for a costume party hosted by Horace Dodge Jr. at his Lake Shore Road home in Grosse Pointe Farms. (Courtesy of the Grosse Pointe Historical Society.)

Six

HOW FIRM
A FOUNDATION

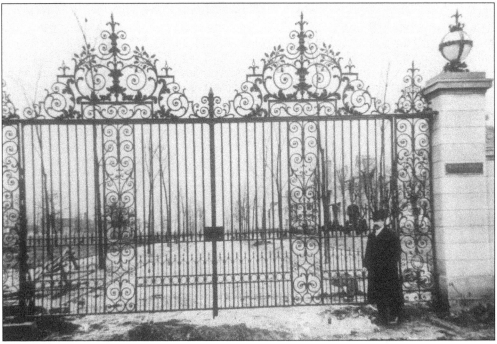

GORGEOUS GATES, C. 1907. These elegant, wrought-iron gates designed by noted Detroit architect Albert Kahn, front the Beverly Road Subdivision. Established in 1910, it was among the first upscale residential developments in Grosse Pointe Farms. As wealthy Detroiters scooped up property along the lake, the Pointe's early settlers began to build houses inland, along Lakeview Avenue, Oak Street (now Muir Road), and Hillcrest Road in Grosse Pointe Farms. Increased property values, coupled with a need to house a growing population of executives and professionals, prompted the development of McKinley Place; Lewiston, Lothrop, and Beverly Roads; and Country Club Park (now Provencal Road). (Courtesy of the Grosse Pointe Historical Society.)

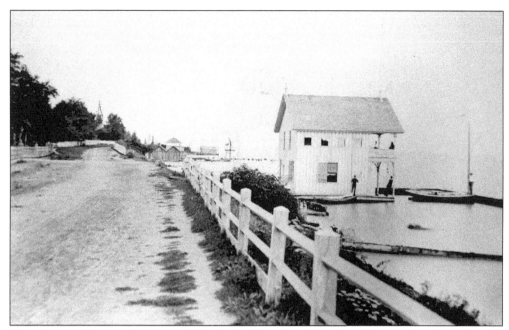

THE GROSSE POINTE ROAD, C. 1880. Lake Shore Road developed from a 9-mile plank toll-road, known as the River Road or Grosse Pointe Road, built in 1851. In 1913, the name was officially changed to Lake Shore Road, though in the City of Grosse Pointe Park, it is referred to as Jefferson Avenue. In 1930–1931, a Wayne County road project extended the land along the shore into the lake with fill taken from the excavations of skyscrapers in downtown Detroit. They created the four-lane divided boulevard that residents travel today. (Courtesy of the Burton Historic Collection of the Detroit Public Library.)

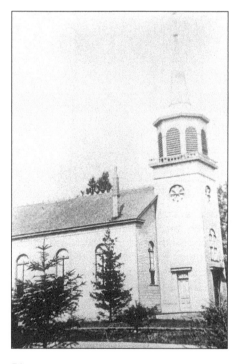

FROM MISSION TO PARISH, C. 1880. Services offered in French echoed through this frame chapel, constructed in 1848 on Lake Shore Road near Lewiston Road in Grosse Pointe Farms. It was the second home of St. Paul's Roman Catholic Parish Church, replacing the original log chapel built in 1825, on the Reno Farm just north of Vernier Road in Grosse Pointe Shores. The church later served as a parish hall until it was dismantled in 1914. Parishioner George Trombley used some of the wood from the old structure to build homes on Notre Dame Road near Maumee Avenue in the City of Grosse Pointe. St. Paul's Cemetery was located directly behind this church until 1868, when it was relocated to a newly purchased 1.8-acre site for burials at Country Club Lane and Moross Road in Grosse Pointe Farms. (Courtesy of the Grosse Pointe Historical Society.)

THE "NEW" ST. PAUL'S CHURCH, C. 1910. In 1895, to accommodate his growing parish, Father John F. Elsen, pastor, initiated the construction of 640-seat St. Paul's Church. Designed by H.J. Rill, the Gothic structure of fieldstone and brick cost $23,329.71. Ironically, the first service held in the new church, on January 7, 1899, was Father Elsen's funeral. (Courtesy of the Grosse Pointe Historical Society.)

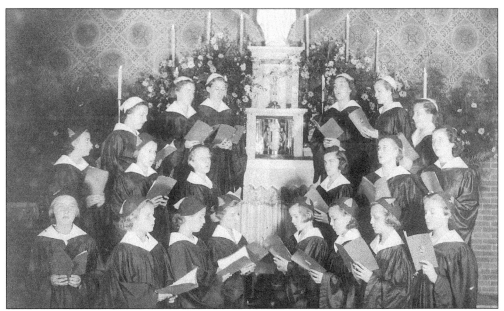

SPIRITUAL NOTES, C. 1930. Members of the St. Clare of Montefalco Parish choir are pictured in the original church, established in 1926, within the parish's elementary school on Audubon and Charlevoix in Grosse Pointe Park. Grosse Pointe's faithful opened several new centers of worship in the 1920s. St. Ambrose Roman Catholic Church was founded in 1916 on Hampton, between Maryland and Wayburn in Grosse Pointe Park, and the Dutch First Christian Reform Church erected a new edifice and opened the Grosse Pointe Christian Day School in 1929 on Maryland in Grosse Pointe Park. (Courtesy of the Catherine Watko Staperfenne Collection.)

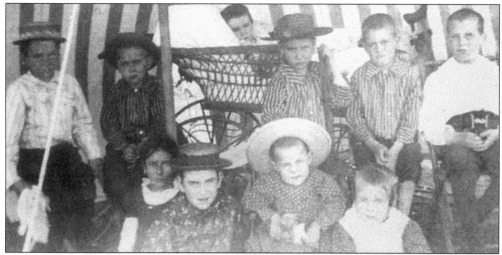

HEALTHFUL BREEZES, C. 1895. These children are thought to be among the youngsters from Detroit area hospitals who enjoyed a recuperative respite at the Lakeside Home for the Convalescent. This charitable institution, located in a vacant summer home near the shores of Lake St. Clair, was established in 1891. (Courtesy of the Grosse Pointe Historical Society.)

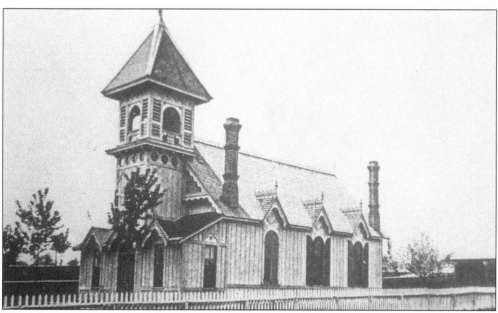

WE GATHER TOGETHER, C. 1885. The Protestant Evangelical Association of Grosse Pointe had been gathering in various locations in the area since 1865. In 1867, they built this Carpenter-Gothic church on land donated by Rufus Kerby, at Kerby Road near Lake Shore Road in Grosse Pointe Farms. Founding members included the Brush, Canfield, Duffield, Lothrop, Michie, and Stewart families. By 1892, when a crowd of Detroit V.I.P.s attending the wedding of society scions Helen Newberry and Henry Bourne Joy overflowed onto the lawn and listened to the ceremony through open windows, it was embarrassingly evident that a new, larger facility was needed. In 1894, this church building was purchased by the newly formed Grosse Pointe Farms Council of Trustees and moved to Kerby Road, between Grosse Pointe Boulevard and Kercheval Avenue, where it served as a Village Hall until 1912. (Courtesy of the Grosse Pointe Historical Society.)

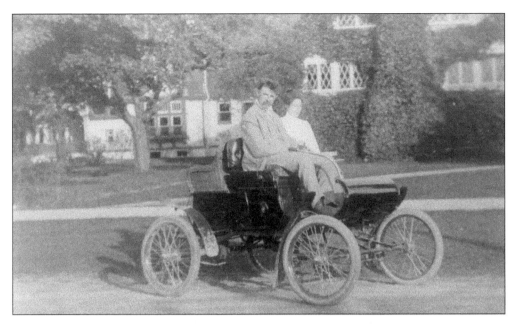

GROSSE POINTE MEMORIAL CHURCH, C. 1900. Henry G. Sherrard, founder of Detroit University School, and his wife, Charlotte Berry Sherrard, drive by the "Little Ivy Covered Church." This charming Mason and Rice-designed building, completed in 1893 at Lake Shore Road and McKinley Place, was the second home of the Grosse Pointe Protestant Church. Unaffiliated in the early years, the congregation became Presbyterian in 1920. The present Neo-Gothic church replaced this structure in 1927. Brothers Truman H. and John S. Newberry offered to donate the new sanctuary in honor of their parents; thus the name was changed to the Grosse Pointe Memorial Church. (Courtesy of the Grosse Pointe Historical Society.)

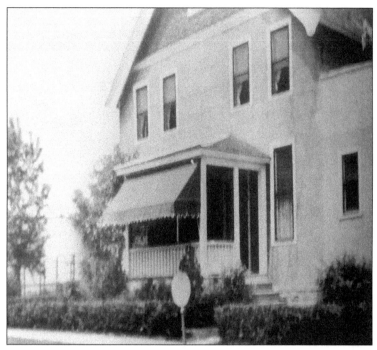

CARE IN A COTTAGE, C. 1919. Cottage Hospital was founded by the Mutual Aid Society Neighborhood Club, following the 1918 Spanish influenza epidemic, which infected approximately 600 Pointers and killed 7. Cottage welcomed its first patients into this house on Muir Road in Grosse Pointe Farms, on March 13, 1919. The hospital flourished, eventually annexing the house next door (lower picture) via a breezeway. The original portion of the present Cottage Hospital was built in 1928 at Kercheval Avenue and Muir Road in Grosse Pointe Farms. (Courtesy of the Cottage Hospital Collection.)

FROM HOME TO HOSPITAL, c. 1924. In 1909, the Roman-Catholic order of the Sisters of *Bon Secours*, or "Good Help," arrived in Detroit from Europe and by 1911, were caring for the indigent and sick in their homes. By 1924, the thrifty nuns were able to purchase a 4-acre tract on the Cadieux farm, at Cadieux Road and Maumee Road in the City of Grosse Pointe. In 1938, they opened an eight-bed convalescent home in this farmhouse on the property. A 36-bed convalescent facility replaced this house in 1941 and was later transformed into a hospital. The present building was enlarged in 1951, 1954, and 1975, to its current capacity of 290 beds.(Courtesy of The Sisters of Bon Secours Hospital.)

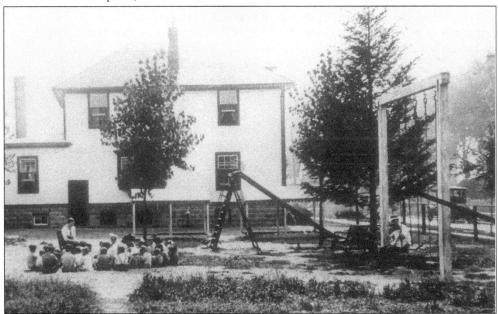

FUN AND GAMES, c. 1912. Children play at the Grosse Pointe Neighborhood Club, located at 60 Oak Street, now Muir Road, in Grosse Pointe Farms. This community center, founded in 1912, was dedicated to providing recreational and educational opportunities and social services to Pointe families, with a special emphasis on those who worked on or serviced the area's great estates. Originally located in the City of Grosse Pointe, it later moved to this site. In 1927, thanks to a generous donation of land by a local benefactor, the facility moved to Waterloo Road and St. Clair Avenue in the City of Grosse Pointe where the present clubhouse now stands. (Courtesy of the Grosse Pointe Historical Society.)

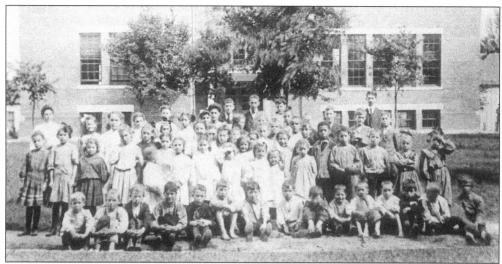

KERBY ELEMENTARY SCHOOL, C. 1909. Students have been attending Grosse Pointe's first public school, Kerby Elementary, for more than a century. The original Kerby School was built in the 1850s on the Michie Farm, on Lake Shore Road between Moran Road and Kerby Road in Grosse Pointe Farms. In 1886, students moved north to a clapboard structure on Kerby Road between Grosse Pointe Boulevard and Kercheval Avenue, near the present Grosse Pointe Farms Municipal offices. This brick building was built in 1905 to replace that old wooden schoolhouse. By 1949, an ever-growing enrollment forced the school to relocate to its present site, on Kerby Road and Beaupre Road in Grosse Pointe Farms. (Courtesy of the Grosse Pointe Historical Society.)

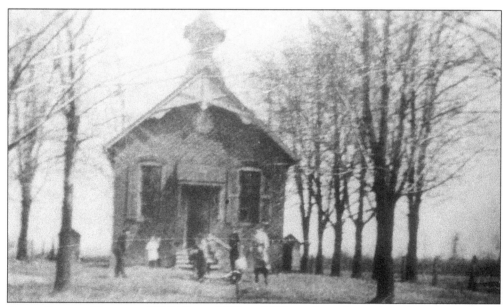

COOK SCHOOL DAYS, C. 1918. From 1890 to 1922, students learned reading, writing, and arithmetic in the one-room Cook School House, part of the Grosse Pointe and Gratiot Townships, Fractional District No. 9, at Mack Avenue near Lochmoor Boulevard in Grosse Pointe Woods. The school was built on land purchased from the ribbon farm of Louis and Matilda Cook. In recent years, the structure has served as a mission, a music studio, and an office. (Courtesy of the Archives of the Marc J. Alan Family.)

MODERN MARVEL, C. 1885. The Academy of the Sacred Heart was part of an international network of day and boarding schools for well born young ladies established by the Roman Catholic Society of the Sacred Heart of Jesus. With such "modern" conveniences as steam heat and running water, the building was recognized as a marvel of modern technology when it opened in September 1885, on a 42-acre campus at Lake Shore Road and Moran Road in Grosse Pointe Farms. In 1899, a Gothic chapel designed in the tradition of La Sainte Chapelle in Amiens, France, was completed. Students adhered to a rigorous academic curriculum and followed a strict moral code based on the motto *Noblesse Oblige*, or "Rank has its Obligations." In 1969, the original charter was transferred to a lay board and the campus became The Grosse Pointe Academy. (Courtesy of The Grosse Pointe Academy Collection.)

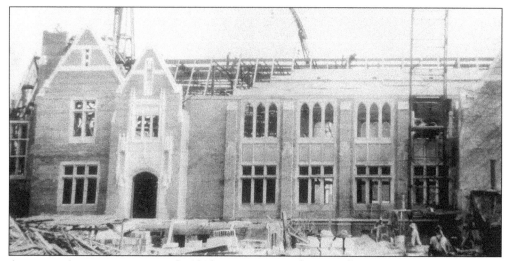

ACADEMY ADDITION, C. 1929. In 1929, an ever-expanding enrollment prompted the addition of a new school building to the Academy of the Sacred Heart campus. This Tudor-Gothic structure, designed by Maginnis and Walsh of Boston, was funded by the sale of the Academy's property running from Grosse Pointe Boulevard to Ridge Road. That land, now Kenwood Road, was named for the Sacred Heart Mother House in Albany, New York. The only remnant of its history is the path of towering maple trees, once part of the Academy's "Nun's Walk," which runs down the lawns of homes on the north side of the street. (Courtesy of The Grosse Pointe Academy Collection.)

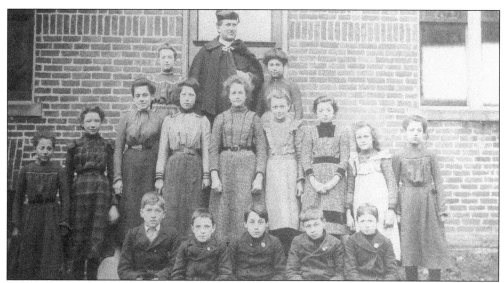

"FREE" SCHOOL, C. 1913. In accordance with their tradition, the Religious of the Sacred Heart built this "free school" in 1886, on Lake Shore Road and Moran Road in Grosse Pointe Farms, for the children of neighboring St. Paul's Roman Catholic parish. The Romanesque-Revival structure was designed by the firm of Stratton and Baldwin of Detroit. The interior of a 1912 addition was lined with tiles created by Stratton's wife, Mary Chase Stratton, founder of Detroit's Pewabic Pottery. In 1927, St. Paul's parish built its own parochial school. The old building then reverted to the Academy of the Sacred Heart and, with another addition in 1987, today serves as The Grosse Pointe Academy Early School. (Courtesy of The Grosse Pointe Academy Collection.)

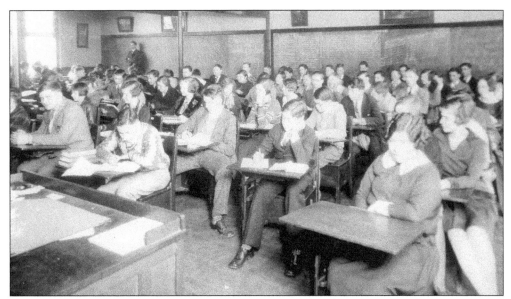

CADIEUX SCHOOL, 1929. Local school districts consolidated in 1922 into the Grosse Pointe Rural Agricultural District No.1. Middle and high school students took public transportation to Detroit schools to finish their education until 1924, when the Cadieux School, on St. Clair Avenue near Lake Shore Road in the City of Grosse Pointe, welcomed grades 7 through 12. The facility currently serves as the Administration Building of the Grosse Pointe Public School System. (Courtesy of the Grosse Pointe Public School System.)

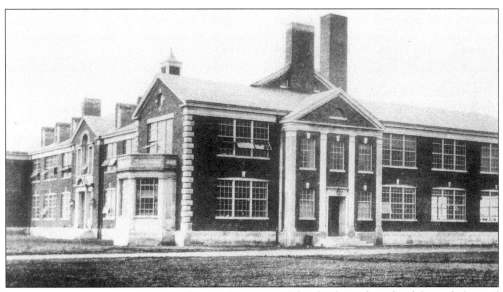

THREE SCHOOLS IN ONE, C. 1928. Detroit University School, a boy's day school formerly located near Detroit's Indian Village historic district, moved to this new school building, on Cook Road near Chalfonte Road in Grosse Pointe Woods, in 1929. In 1941, D.U.S. merged administratively with Grosse Pointe Country Day School. The two schools become one, under the name Grosse Pointe University School, in 1953. The Liggett School, a private female academy, moved from Indian Village to Briarcliff Road in Grosse Pointe Woods in 1965 and merged with GPUS in 1969 to create today's University Liggett School. (Courtesy of the University Liggett School Archives.)

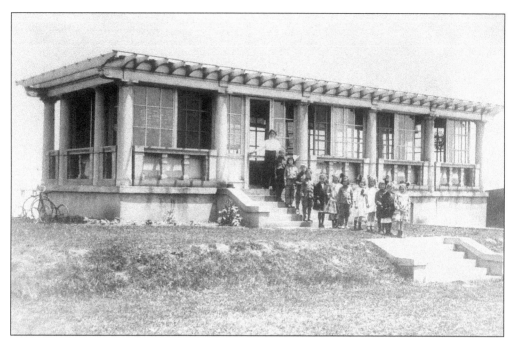

INDEPENDENT INITIATIVES, C. 1916. Quarantine during the 1914 typhoid fever epidemic in Detroit prompted the founding of the Grosse Pointe School. Students were tutored in the Alger boat house (above) on Roosevelt Place in the City of Grosse Pointe. In 1916, the co-educational private day school moved to this building (below), on Grosse Pointe Boulevard near Meadow Lane, in Grosse Pointe Farms. The school was renamed Grosse Pointe Country Day School in 1929 and the curriculum expanded to include high school courses in 1940. (Courtesy of the University Liggett School Archives.)

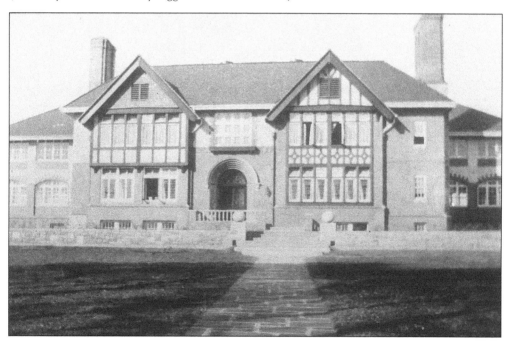

PARK POLITICS, 1905. A 5¢ fare on streetcars and an improved water system were two key planks in the platform of these civic-minded gentlemen running for officer positions in the Village of Fairview. Once part of Grosse Pointe Township, this small municipality was a favorite retail district. When Fairview was incorporated in 1907, the tract of land running from Alter Road to Cadieux Road between the Detroit River/Lake St. Clair and Mack Avenue, became Grosse Pointe Park while the rest was absorbed into the City of Detroit. (Courtesy of the Garska Family Archives.)

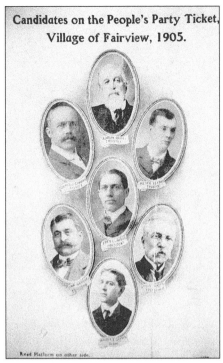

Candidates on the People's Party Ticket, Village of Fairview, 1905.

MR. MAYOR AND FAMILY, C. 1913. Parked in front of Grosse Pointe Farms Mayor Dan Allard's general store, on Kerby Road near Ridge Road in Grosse Pointe Farms are, from left to right, Dan Allard, Harold Allard, and Walter C. Allard. Dan's wife Rose is shown holding their son Sid Allard. Also pictured are Rose's brother Alfred Frazer and his girlfriend. The Pointe boasts both Allor and Allard families, most of whom descended from the same French forebearers. Alterations in the family names of many of the area's early settlers can be traced to spellings appearing in the register of St. Paul's Roman Catholic Church in Grosse Pointe Farms where they fell prey to the literacy level of the recorder. (Courtesy of the David W. Allard Collection.)

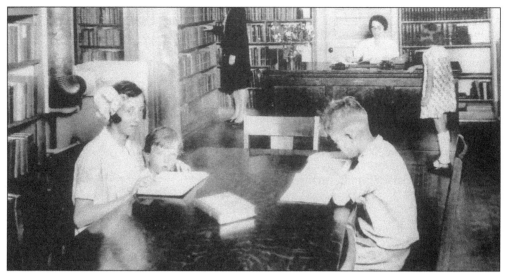

SSSHHH! C. 1926. These readers could open a world of knowledge from the more than 4,000 books in the Wayne County Library's Grosse Pointe Collection, some of which were housed in this Waterloo branch. Additional branches were located on Mack Avenue and Lochmoor Boulevard in Grosse Pointe Woods, in the basement of the Farms Municipal Building, in the Grosse Pointe Shores Village Hall and later in the basement of the Grosse Pointe Park Municipal Building. By the late 1920s, the innovative librarians also established a "bookmobile" that moved throughout the neighborhoods. (Courtesy of the Grosse Pointe Historical Society.)

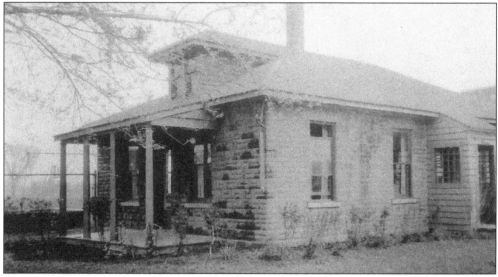

VOLUMES OF KNOWLEDGE, 1928. The Grosse Pointe Public Library system grew out of a 221-volume collection assembled by the Protestant Society of the Little Ivy Covered Church. The first Wayne County branch was opened in the basement of the Grosse Pointe Shores Village Hall in January 1922. Another branch was housed in the Neighborhood Club cottage until the Club moved to a new facility. In 1926, the branch moved to this adjacent house, on Waterloo near St. Clair Avenue in the City of Grosse Pointe. Pointer Dexter M. Ferry of the Ferry Seed Company—the largest seed manufacturer in the United States—donated it. (Courtesy of the Grosse Pointe Historical Society.)

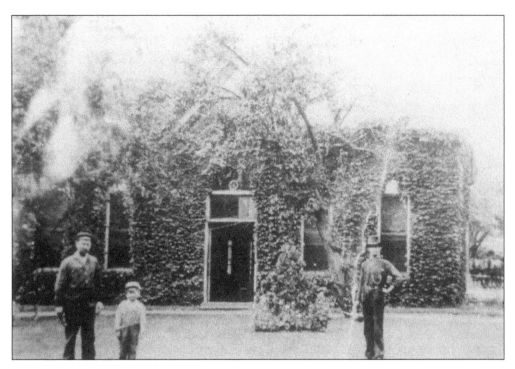

FRESH WATER, C. 1932. The new Grosse Pointe Farms Water Filtration Plant (below), designed by noted architect Robert O. Derrick, opened at the corner of Moross Road and Grosse Pointe Boulevard in 1932. This facility dwarfed the original Queen Ann style plant (above), which still shares the property. The latter was built by the Grosse Pointe Water Company in 1893 to serve Lake Shore residents and was sold to the City of Highland Park in the 1920s. During Prohibition, the Highland Park plant served as a signal post for rumrunners who flashed red or green lights from its windows to notify their associates on the Canadian shore when it was safe to sail or drive across the Lake. (Courtesy of the Ignatius Backman Family Collection/City of Grosse Pointe Farms.)

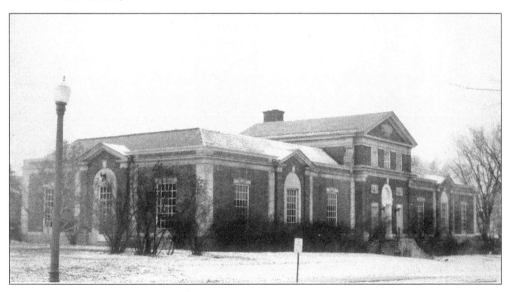

TAMING THE BLACK MARSH, C. 1922. Black Marsh ditch, known today as Chalfonte Road in Grosse Pointe Farms, was said to be used as a foul-weather water route by Indians and early French "habitants" to paddle from the Detroit River to Lake St. Clair. In the late 1920s it was drained as part of a major sewage system improvement program. The pipe, shown here at the corner of Kerby Road and Chalfonte Avenue in Grosse Pointe Farms, was big enough to drive a truck through. (Courtesy of the Ignatius Backman Family Collection/City of Grosse Pointe Farms.)

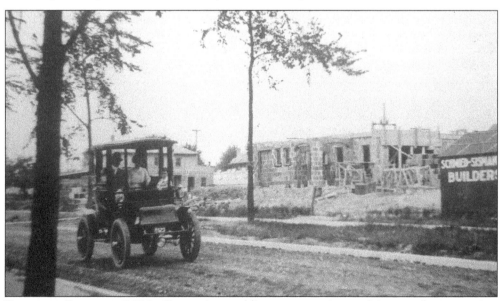

BUILDING BOOM, C. 1911. Convenient public transportation and increased city services convinced more and more families to make permanent homes in the Pointes. Farmers' fields and sprawling estates began to give way to neat, tree-lined subdivisions like Lincoln Road in the City of Grosse Pointe, pictured here. (Courtesy of Sally Cudlip Archives.)

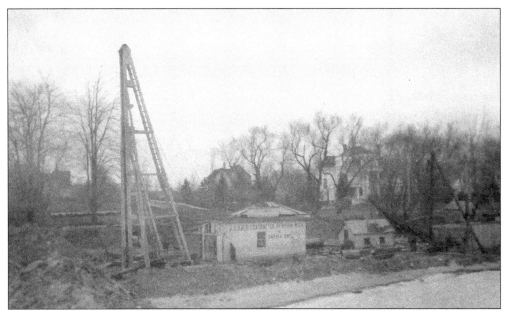

PIER PARK EXCAVATION, C. 1914. Civic-minded residents of Grosse Pointe Farms first petitioned for a public park in 1909. In 1911, voters approved the purchase of property at Lake Shore Road and Moross Road. This photograph shows the early excavation. Today, each of the five Grosse Pointe municipalities includes at least one public park offering residents pools, beaches, boating facilities, tennis courts, and picnic areas. (Courtesy of the Grosse Pointe Historical Society.)

BONE COLLECTOR, C. 1918. Like many who dug into the soil of Windmill Pointe in Grosse Pointe Park, this laborer discovered relics of the more than 1,000 Fox Indians massacred by French soldiers in 1712. An inscription on this photo reads, "My father worked for the contractor McIntre. [The] Job involved building a sea wall, filling in low ground and leveling sand hills. In the process of leveling, many Indian skeletons were exposed. The man in the picture, known only as the bum, helped my father gather the bones and store them in a shed. When the contract was nearly finished 'the bum' disappeared… and so did the bones." (Courtesy of the Grosse Pointe Historical Society.)

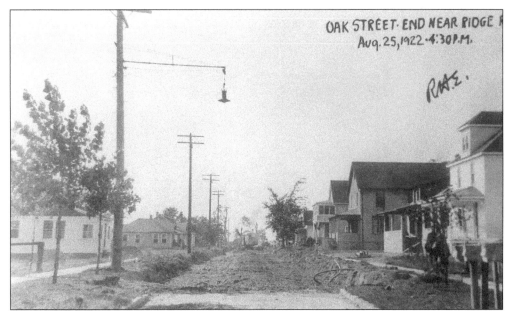

INCUBATOR ALLEY, C. 1922. This early subdivision, originally called Oak Street (now Muir Road) in Grosse Pointe Farms, was home to many of the chauffeurs, gardeners, domestics, and craftsmen who serviced the great estates. These modest frame houses held so many large families that the area was called "Incubator Alley." (Courtesy of the Ignatius Backman Family Collection/City of Grosse Pointe Farms.)

INROADS OF PROGRESS, C. 1923. This gate was built at Cloverly Road and Grosse Pointe Boulevard in Grosse Pointe Farms. The streets of Grosse Pointe form an irregular pattern because many follow the boundaries of the old French and Belgian "ribbon farms," summer properties, and estates for which they were named. (Courtesy of the Grosse Pointe Historical Society.)

MINDING THE STORE, C. 1924. Augusta Verfaillie and her daughter, Stella, service customers at their dry-goods store, called The Grosse Pointe Shop, at Kercheval Avenue and Notre Dame in the City of Grosse Pointe. The shop was located in one of the first storefront buildings in the commercial area. Later, Mrs. Verfaillie's father Henry Huvaere added two adjoining buildings, still used as retail space, just north of the store on Kercheval. Until the 1960s, the family lived in one of three apartments, located behind and above the store. (Courtesy of the DeRonghe Family Collection.)

VILLAGE VIEW, C. 1930. The Village commercial district, in the City of Grosse Pointe, grew from a collection of businesses in clapboard homes, along Field Avenue, which became Kercheval Avenue in 1887. Until 1930, the stores and restaurants stretched along a narrow dirt road. When Fred Knuff built the original Notre Dame Pharmacy at the corner of Notre Dame and Kercheval Avenue, business was low-key, to say the least. After Knuff assured a caller that the pharmacy would cash her check, she replied, "Please send the money over right away … I'll drop off the check tomorrow!" The transaction was completed without further inquiry. (Courtesy of the Grosse Pointe Historical Society.)

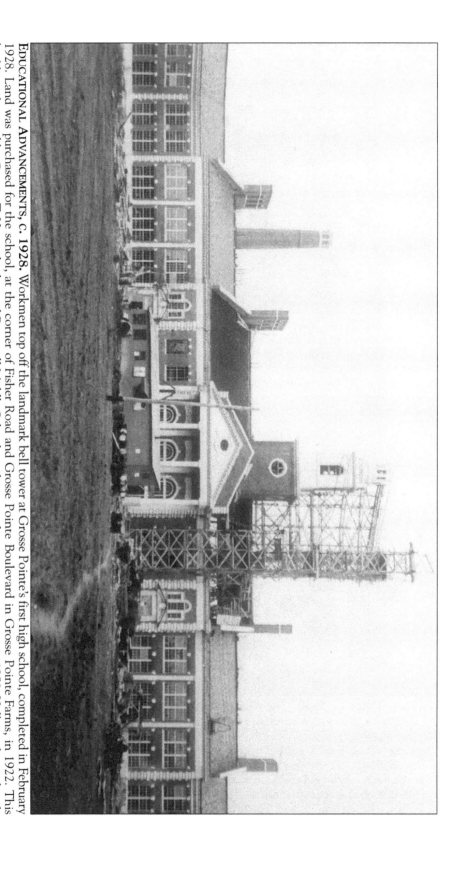

EDUCATIONAL ADVANCEMENTS, C. 1928. Workmen top off the landmark bell tower at Grosse Pointe's first high school, completed in February 1928. Land was purchased for the school, at the corner of Fisher Road and Grosse Pointe Boulevard in Grosse Pointe Farms, in 1922. This building, designed by George T. Haas, also housed Brownell Middle School until it moved to a separate campus in 1958. Hallways boast details executed in tiles from Detroit's famous Pewabic Pottery. This structure has been known as Grosse Pointe South High School since 1969, when increased enrollment prompted the building of Grosse Pointe North High School on Vernier Road in Grosse Pointe Woods. (Courtesy of the Burton Historical Collection of the Detroit Public Library.)

Seven

AIN'T WE GOT FUN

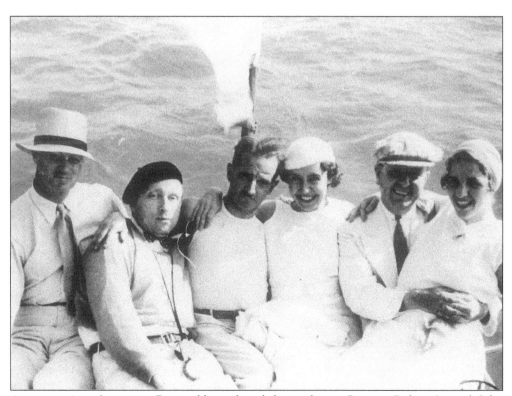

ANCHORS AWAY! C. 1930. Pictured here, from left to right, are Pointers Robert Stoepel, John Stroh, Harold DuCharme, Madelaine Mulkey, Claude Mulkey, and Lou Stroh enjoying a sail on Lake St. Clair. (Courtesy of the Grosse Pointe Club Archives.)

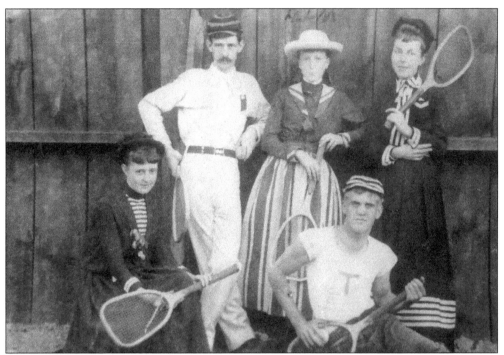

Tennis Anyone? c. 1888. Marian Lewis Muir, standing center, poses with pals before taking to the tennis court. (Courtesy of the Sally Cudlip Archives.)

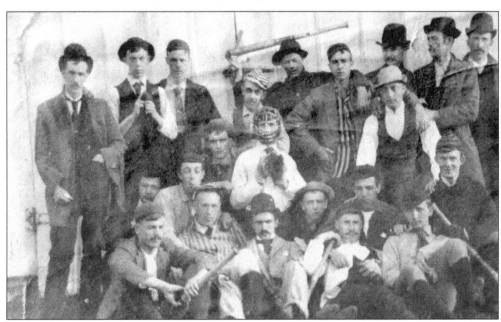

Rag Tag Team, c. 1900. As these baseball players demonstrate, then as now, all you need for a great game are good friends and an open field. One favorite venue was Hamilton Park, near the present day Voltaire Place in Grosse Pointe Farms. The new pastime was so popular that passengers on fashionable Great Lakes freighter cruises played on deck, batting dozens of balls overboard in pursuit of a home run! (Courtesy of the Sally Cudlip Archives.)

A LASS ON THE LINKS, C. 1901.
Mrs. William Howie Muir shows off
her championship form on the greens
of the old Country Club of Detroit.
Golf in Grosse Pointe dates back to
1893, when Senator James McMillan
and Philip McMillan, inspired by a trip
to Wales, coaxed a group of farmers to
create a six-hole course at Hamilton
Park—a parcel of land they owned near
the present site of Voltaire Place in
Grosse Pointe Farms. The Country Club
of Detroit opened its own greens and
joined the fledgling United States Golf
Association in 1898. (Courtesy of the
Sally Cudlip Archives.)

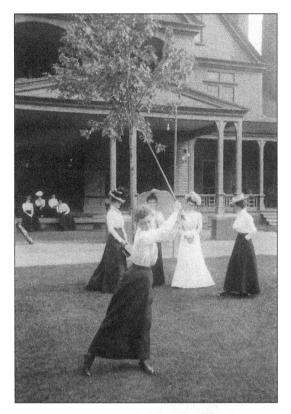

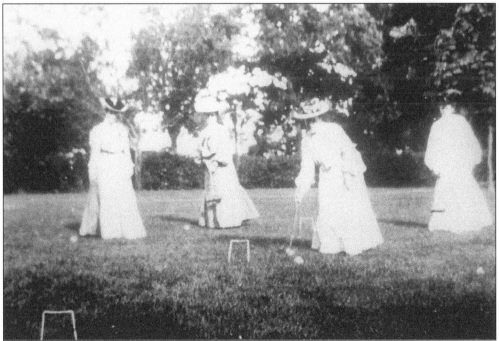

STICKY WICKETS, C. 1900. Country Club of Detroit members amble away a summer afternoon
playing croquet. (Courtesy of the Sally Cudlip Archives.)

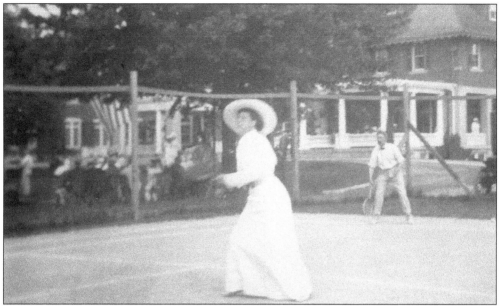

MIXED DOUBLES, C. 1907. Sets of mixed doubles, with Mrs. W. Howie Muir in the forecourt at the Country Club of Detroit, could get pretty heated in elegant but cumbersome tennis togs. (Courtesy of the Sally Cudlip Archives.)

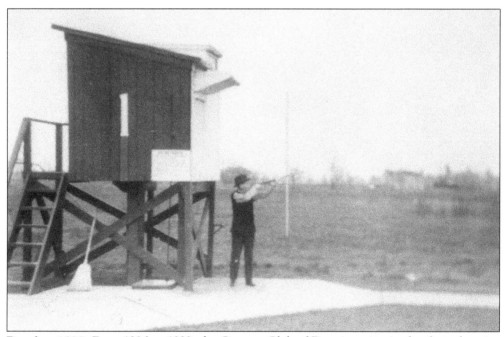

PULL! C. 1930. From 1926 to 1939, the Country Club of Detroit maintained a skeet-shooting field, including two trap-shooting houses and eight shooting stations, between Mack Avenue and Chalfonte Road on the Grosse Pointe Farms/Grosse Pointe Woods border. The Club boasted several state and national champions including Henry B. Joy, James McMillan, and Mrs. Sidney Small. The old Detroit University School building, now University Liggett School, can be seen in the background. (Courtesy of the Grosse Pointe Historical Society.)

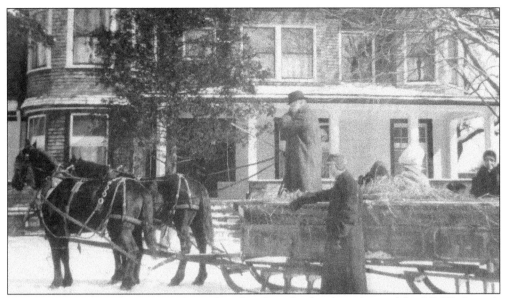

SLEIGH BELLS JINGLED, C. 1909. Friends gather for a sleigh ride in front of the S.P. Wadsworth home on Lake Shore Road near Berkshire Place in Grosse Pointe Farms. Dating back to the earliest French settlers, sleighs were an important source of transportation and fun. *Les habitants* would hitch their shaggy ponies to simple rigs and race over the frozen waters of the Grand Marais in Grosse Pointe Park. (Courtesy of the Sally Cudlip Archives.)

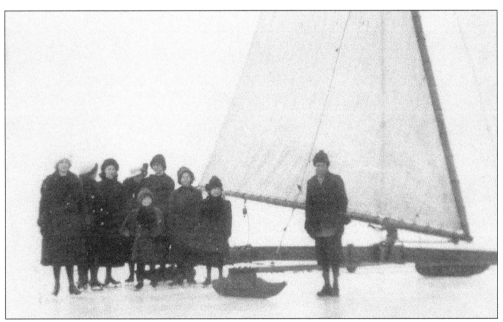

BURRRRR! C. 1912. George Hendrie (far right), who grew up to be one of the Pointe's champions ice boaters, inspects his craft with a little help from his friends. Whipped by the bitter winter winds, iceboats raced at speeds in excess of 70 miles per hour. At the dawn of the 20th century, before waste from industrialization and urban sprawl warmed the waters of Lake St. Clair, the surface would freeze solid from the American to the Canadian shore. (Courtesy of The Grosse Pointe Academy Archives.)

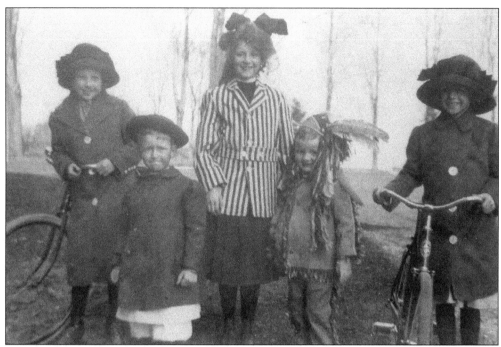

ONE LITTLE INDIAN BOY, C. 1912–1917. Grosse Pointers Elizabeth and Alexander Lewis, Peggy Sefton, Brooks Nichols, and Annette Lewis play the day away. (Courtesy of The Grosse Pointe Academy Collection.)

FAIRY PRETTY, C. 1912–1917. Reveling in a world of make believe at the bottom of a garden are a trio of fairies including H. Cliff (center) and I. Roney (right). (Courtesy of The Grosse Pointe Academy Collection.)

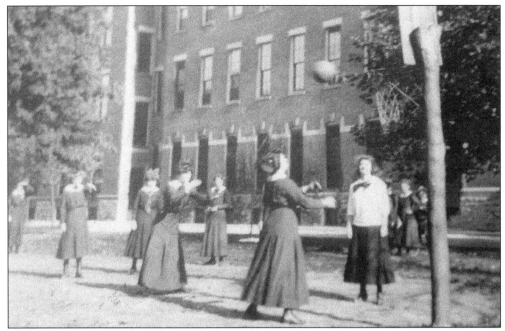

PASS AND SHOOT, C. 1912–1917. Young ladies attending the Academy of the Sacred Heart, at Lake Shore Road and Moran Road in Grosse Pointe Farms, enjoy athletic as well as academic challenges. Here they play a spirited game of basketball behind the "old building," which now houses the administrative offices of The Grosse Pointe Academy. (Courtesy of The Grosse Pointe Academy Collection.)

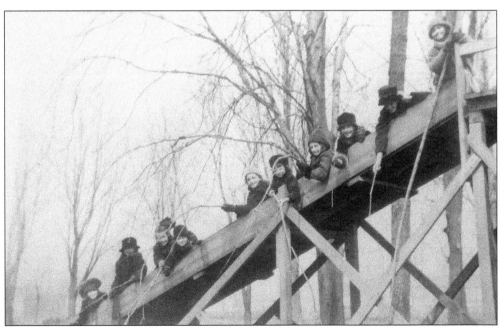

ON THE RUN, C. 1912. Long after the snow melted, students at the Academy of the Sacred Heart enjoyed playing on the high, wooden-toboggan slide. (Courtesy of The Grosse Pointe Academy Archives.)

A MILE FROM THE BREAKWATER, C. 1912–1917. These game girls, M. Nester and K. Bermingham, ventured out on the ice in front of the Academy of the Sacred Heart. Also viewed in the background, on the right, is the home of Mrs. Helen DeMoral Nichols. The house was later demolished and the property was purchased by the school. Today, it remains a part of The Grosse Pointe Academy campus. (Courtesy of The Grosse Pointe Academy Collection.)

REAL TEDDY BEAR, C. 1915. Little Adelaide Lodge and friend visit a real live Teddy Bear house at her father's home at Lake Shore Road near Sunset Lane in Grosse Pointe Farms. (Courtesy of the Grosse Pointe Historical Society.)

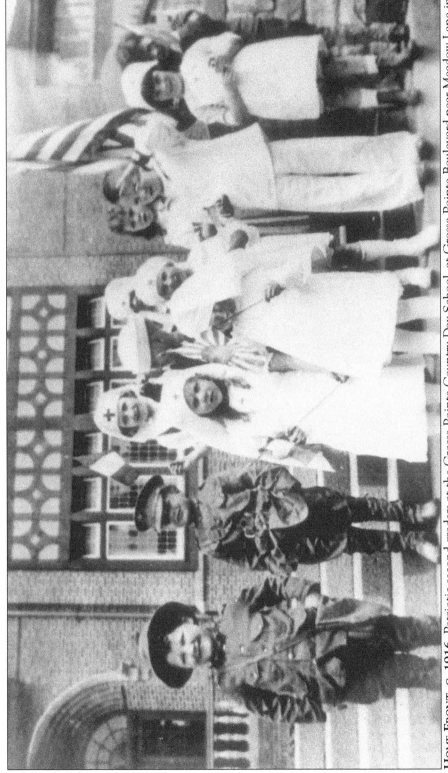

HOME FRONT, c. 1916. Patriotic second graders at the Grosse Pointe Country Day School, at Grosse Pointe Boulevard near Meadow Lane in Grosse Pointe Farms, show their support for the troops fighting in World War I. In addition to dressing up, the children also knitted blankets and collected candy and cigars for soldiers in training camps. Grosse Pointe Country Day School would later become part of University Liggett School. (Courtesy of University Liggett School Archives.)

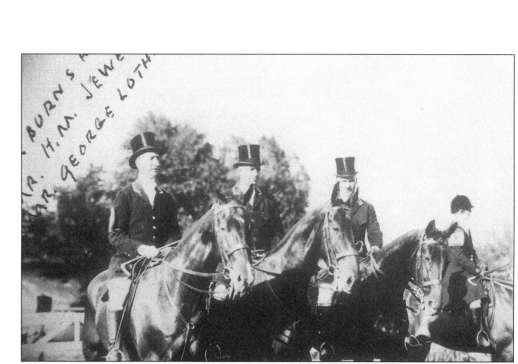

IN THE HABIT, 1920. Pointe equestrians Captain Burns Henry, H.M. Jewett, and George Lothrop cut dapper figures in their riding habits at the Grosse Pointe Riding and Hunt Club's 1920 Horse Show. Henry and Lothrop helped found the Club in 1911, along with Elliott S. Nichols, Colonel Frederick M. Alger, and Wesson Seyburn. The old August Cook home, on Cook Road in Grosse Pointe Woods, still serves as the G.P.H.C. Clubhouse. (Courtesy of the Grosse Pointe Hunt Club Archives.)

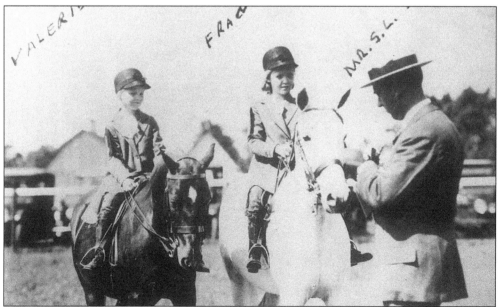

DADDY'S LITTLE GIRLS, 1920. Mr. S.L. Depew of Grosse Pointe adjusts daughter Frances Depew's bridle as her sister Valerie Depew looks on during the 1920 Grosse Pointe Riding and Hunt Club Horse Show on Cook Road in Grosse Pointe Woods. (Courtesy of the Grosse Pointe Hunt Club Archives.)

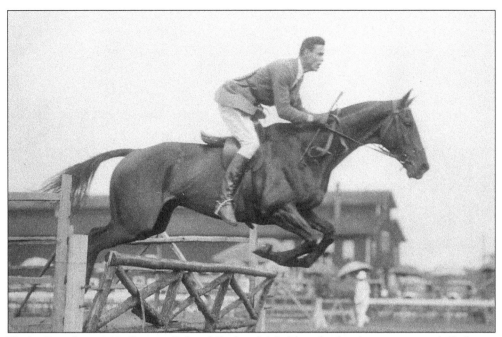

UP 'N OVER! C. 1927. Pointer Colonel Frederick M. Alger displays his equestrian skills during the Grosse Pointe Riding and Hunt Club's Horse Show. (Courtesy of the Grosse Pointe Hunt Club Archives.)

POLO ANYONE? 1929. Charles L. Palms Jr. wields his mallet in a heated chukker on the Grosse Pointe Riding and Hunt Club's field, on Cook Road in Grosse Pointe Woods. On Wednesdays and weekends, Country Club of Detroit Polo players—including William K. Muir, Gary Stroh, Fred Alger, and Charles Palms—put their passion for the game to the test against teams from Toledo, Chicago, Cleveland, and Buffalo. The C.C.D. Polo field was located just west of Fisher Road in Grosse Pointe Farms. (Courtesy of the Grosse Pointe Hunt Club Archives.)

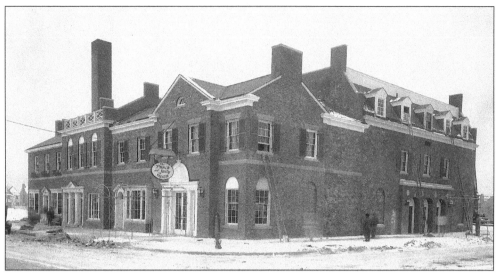

MAGNIFICENT MOVIE HOUSE, C. 1930. Offering an escape from the Great Depression was Grosse Pointe's swellest cinema—the Punch and Judy Theatre. This Robert O. Derrick-designed movie house was located at Kercheval Avenue and McKinley Road in Grosse Pointe Farms's "Upper Village" commercial district, now known as "The Hill." The elegant clientele could avoid confronting the crowds by making reservations to view films from the second floor loge. A doorman and carhops also made movie-going a carefree experience. The building now houses commercial offices. (Courtesy of the Detroit News Collection/Walter P. Reuther Library, Wayne State University.)

FREEZING WITH FRIENDS, 1923. Friends Bert Robarge, Bernadine Beaupre, Clarence Dorsey, Catherine "Kelly" Beaupre, and Frank McPhillips slip, slide, and glide on Lake St. Clair. McPhillips was later ordained and presided over St. Paul's Roman Catholic Parish in Grosse Pointe Farms as Monsignor McPhillips, pastor from 1958 to 1971. (Courtesy of the Mr. and Mrs. Albert E. Beaupre Family Collection.)

BATHING BEAUTIES, C. 1915. Josephine Alger and Marion Scherer catch the summer sun on the dock of the Scherer boathouse at Lake Shore Road and Moran Road in Grosse Pointe Farms. Josephine spent her childhood at The Moorings, her family's estate on Lake Shore Road at Elm Court in Grosse Pointe Farms which now serves as The Grosse Pointe War Memorial community center. (Courtesy of the H. Livingstone Bogle Collection.)

SETTING SAIL, C. 1930. Russell A. Alger III sets sail on his graceful sloop in the waters off his parents' home, The Moorings. The Grosse Pointes still boast one of the highest concentrations of registered watercraft in the United States. (Courtesy of the Grosse Pointe War Memorial Association.)

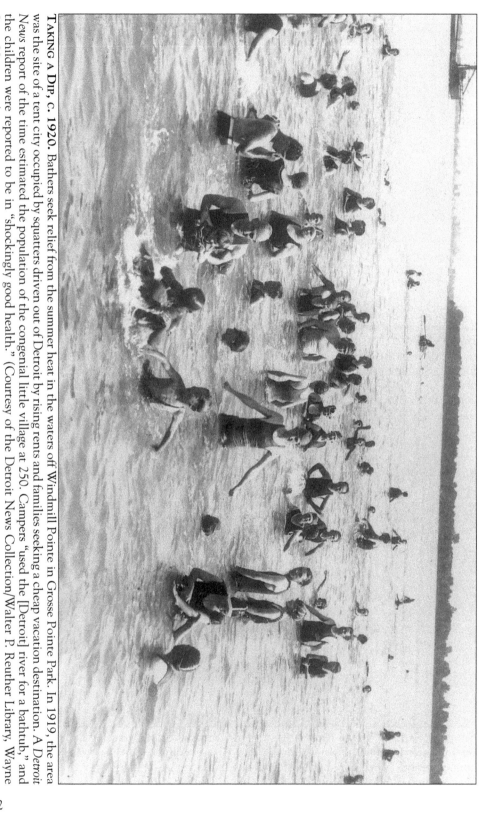

TAKING A DIP, C. 1920. Bathers seek relief from the summer heat in the waters off Windmill Pointe in Grosse Pointe Park. In 1919, the area was the site of a tent city occupied by squatters driven out of Detroit by rising rents and families seeking a cheap vacation destination. A *Detroit News* report of the time estimated the population of the congenial little village at 250. Campers "used the [Detroit] river for a bathtub," and the children were reported to be in "shockingly good health." (Courtesy of the Detroit News Collection/Walter P. Reuther Library, Wayne State University.)

Eight

I'M SITTING PRETTY IN A PRETTY LITTLE CITY

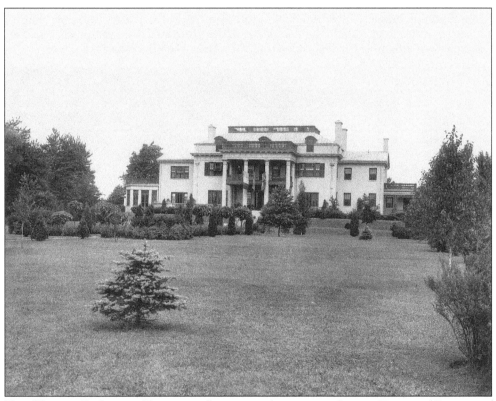

THE WALTER B. CARREY ESTATE ON JEFFERSON AVENUE, IN GROSSE POINTE. (Courtesy of Manning Brothers Archives.)

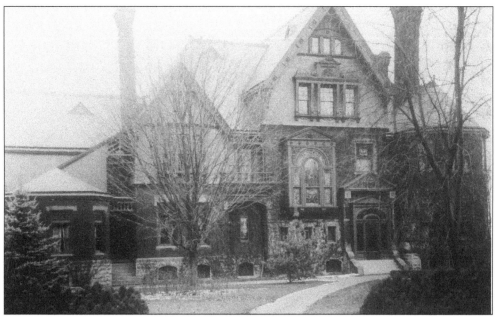

EDGEMERE, C. 1900. One of the first year-round houses in the Pointes belonged to Joseph Berry, founder and president of the Berry Paint and Varnish Company. Designed by famed architects Mason and Rice in the Queen-Ann style, the magnificent mansion was built in 1882 on Lake Shore Road near Edgemere Road in Grosse Pointe Farms. A widower, Berry led a comparatively secluded, private life and devoted his energies to his three daughters and a passion for gardening. The home was demolished in 1942. (Courtesy of the Grosse Pointe Historical Society.)

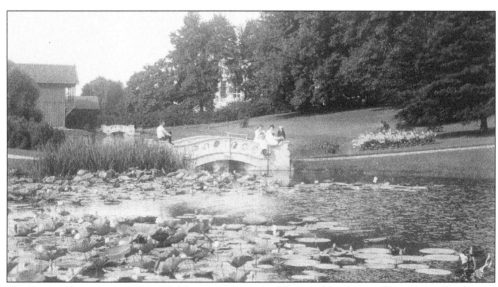

PASTORAL PEACE, C. 1900. Children perch atop a lily pond bridge in the artistically elegant gardens of Edgemere. Berry surrounded his family with beauty, setting his home in a perfect pastoral scene complete with formal floral beds and sparkling lagoons. To maintain his plantings, the innovative Mr. Berry installed what may have been the Pointe's first sprinkler system, comprised of steam engines that forced water through underground pipes. (Courtesy of the Grosse Pointe Historical Society.)

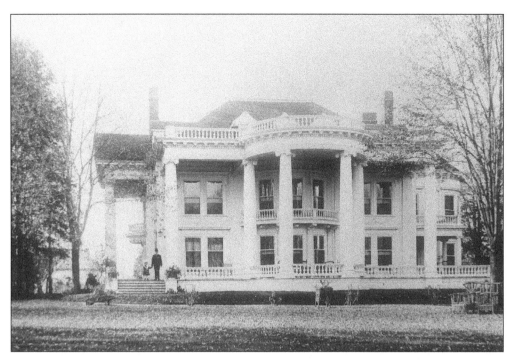

SCHERER HOUSE, C. 1904. Inspired by the Old South, architect Louis Kamper designed this Colonial-Revival summer home for Detroit wholesaler Hugo Scherer. The massive white clapboard house, built in 1898 on Lake Shore Road and Moran Road in Grosse Pointe Farms, later became the family's year-round residence. It was demolished in 1984. (Courtesy of the H. Livingstone Bogle Collection.)

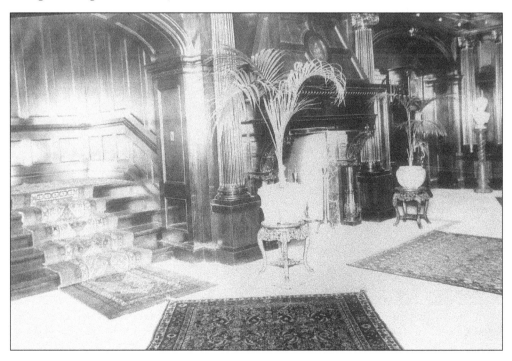

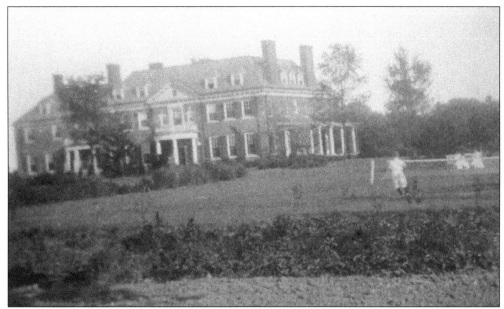

LAKEWOOD COURT, C. 1910. Guests of the John M. Dwyer family could enjoy tennis anytime on their side yard lawn at Lakewood Court. Mr. Dwyer was secretary of the Peninsular Stove Company, one of the firms that gave Detroit a national reputation for stove building in the late-19th century. The house, designed by Britain's Raymond Carey and completed in 1909, stood amidst a lush formal garden on Jefferson Avenue, in the City of Grosse Pointe. When the property was subdivided to create Lakeland Road, the home was turned to face Lakeland Avenue, where it still stands. (Courtesy of the Grosse Pointe Historical Society.)

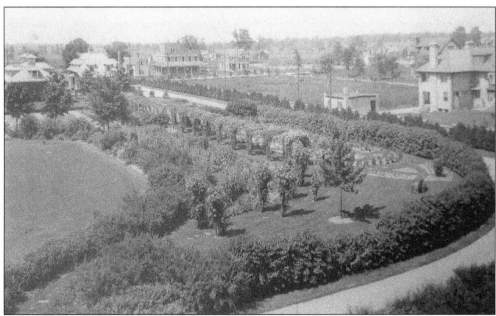

VIEW FROM THE GARDENS, C. 1910. This aerial view offers a glimpse of the magnificent garden surrounding the Georgian manor built by John M. Dwyer, and also shows the Castle Roadhouse then on Maumee in the distance. (Courtesy of the Grosse Pointe Historical Society.)

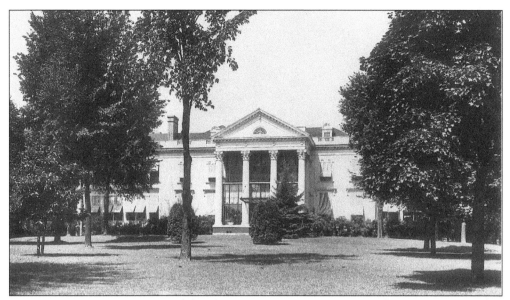

RIDGEMONT, C. 1920. Inspired by the Executive Mansion in Washington D.C., Walter McFarlane designed this classically-palatial summer home for real estate developer David C. Whitney. The house, completed in 1902, was located on Lake Shore Road near Winthrop Place in Grosse Pointe Farms. It was demolished in 1956. (Courtesy of the Grosse Pointe Historical Society.)

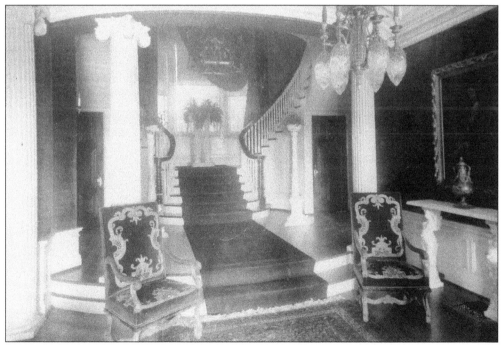

WHITNEY INTERIOR, C. 1913. Pictured is the lush interior of Ridgemont, David Whitney's Grosse Pointe home. Mr. Whitney was an avid collector of all things Oriental, while Mrs. Whitney was a confirmed Francophile whose boudoir was a replica of Marie Antoinette's at Versailles. (Courtesy of the Burton Historical Collection of the Detroit Public Library.)

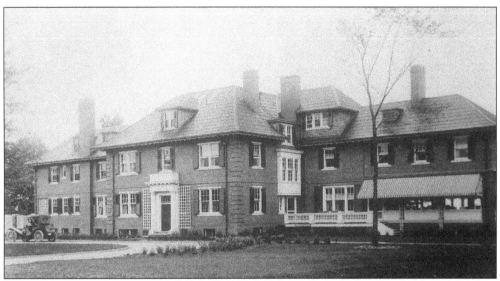

FAIR ACRES, C. 1913. In 1909, Packard Motor Car Company President Henry Bourne Joy built this Albert Kahn-designed house and boathouse on his estate, Fair Acres, on Lake Shore Road near Kerby Road, in Grosse Pointe Farms. During Prohibition, Mr. Joy had to chase more than a few bootleggers and trigger happy federal agents off his property when the estate's boathouse, located on a stony point jutting out into Lake St. Clair, became a favorite landing for rumrunners. Though the home was demolished in 1959, the Joy boathouse has been used as the clubhouse for Crescent Sail Club since 1934. Mrs. Joy reigned supreme in society circles from the 1880s until her death in 1958. Well into the mid-1950s, her favored means of conveyance was a 1914 navy-blue electric car. (Courtesy of The Manning Brothers Archives.)

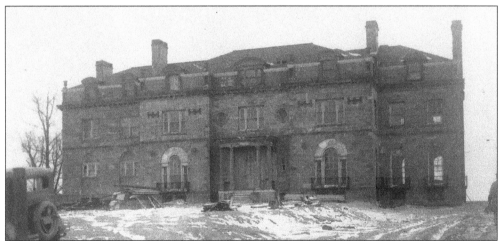

MANSION ON THE MOVE, C. 1913. John B. Ford's Italian manor was built in 1904 on property overlooking the Detroit River along E. Jefferson Avenue, in Detroit's fashionable Indian Village neighborhood. In 1913, it was dismantled and moved to its present site on Windmill Pointe Drive near Westchester Road in Grosse Pointe Park. Mr. Ford was the son of Captain John B. Ford of Pittsburgh, founder of the Pittsburgh Plate Glass Company and the Michigan Alkali Company. He, and his progeny, would come to be known locally as the "chemical" Fords to distinguish them from the "automotive" Fords who were of no relation until Edsel Ford's daughter, Josephine Clay Ford, married into the family. (Courtesy of the Grosse Pointe Historical Society.)

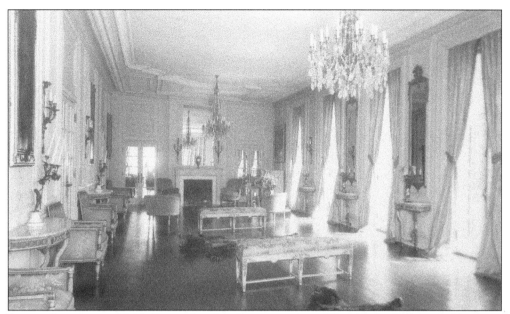

LAP OF LUXURY, C. 1911. Pictured is the elegant interior of Deeplands, the home of financier Henry D. Shelden and his wife Caroline. Chicago's Arthur Heun designed this Italian villa, which stood on Lake Shore Road near Deeplands Road in Grosse Pointe Shores. The aptly named estate included 80 acres of prime property. To gauge the enormity of this home and property, where once this single mansion reigned supreme, more than 80 custom-built family homes, in the $300,000 to $1 million range now stand. (Courtesy of the Grosse Pointe Historical Society.)

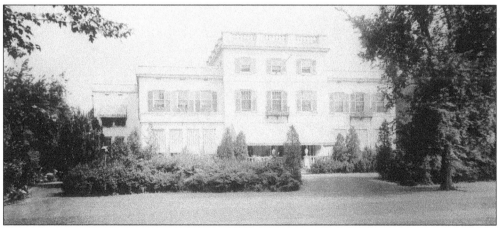

GRANDEUR AND GRIEF, C. 1920. In 1917, plumbing supply manufacturer Murray W. Sales presented his family with Edgeroad, a Louis Kamper-designed Italian-Renaissance villa, still standing near Lake Shore Road and Lincoln Road in the City of Grosse Pointe. Just two years later, tragedy struck when the Sales's 12-year-old son and 22-year-old daughter, along with a guest and two servers, died from botulism poisoning after eating improperly preserved black olives during a dinner party. Turning his grief into positive action, Mr. Sales spearheaded a successful national campaign to improve laws protecting consumers of canned food goods. In 1926, following the death of his 23-year-old son in a car accident, Mr. Sales donated $100,000 in his children's names to help build Cottage Hospital in Grosse Pointe Farms. (Courtesy of the Burton Historical Collection of the Detroit Public Library.)

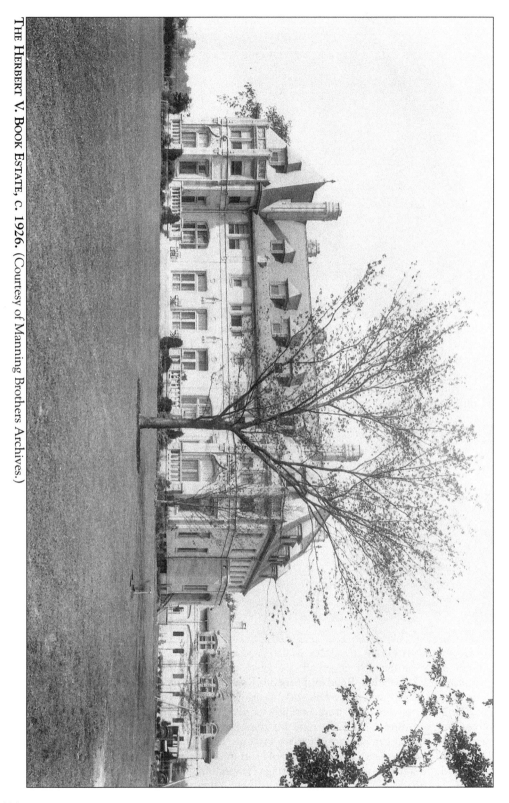

THE HERBERT V. BOOK ESTATE, C. 1926. (Courtesy of Manning Brothers Archives.)

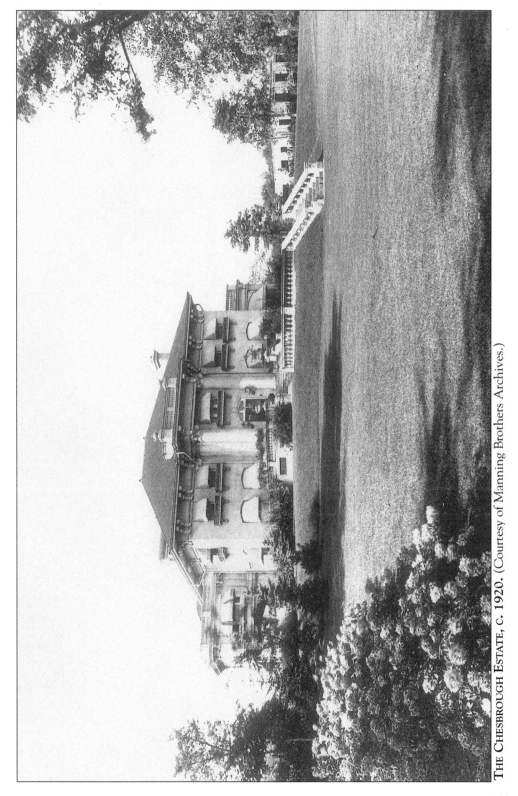

THE CHESBROUGH ESTATE, c. 1920. (Courtesy of Manning Brothers Archives.)

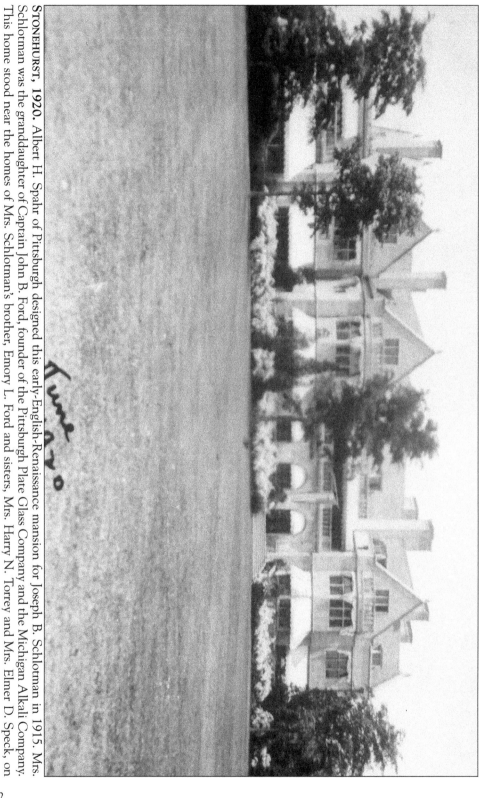

STONEHURST, 1920. Albert H. Spahr of Pittsburgh designed this early-English-Renaissance mansion for Joseph B. Schlotman in 1915. Mrs. Schlotman was the granddaughter of Captain John B. Ford, founder of the Pittsburgh Plate Glass Company and the Michigan Alkali Company. This home stood near the homes of Mrs. Schlotman's brother, Emory L. Ford and sisters, Mrs. Harry N. Torrey and Mrs. Elmer D. Speck, on Lake Shore Road near the present Stonehurst Road in Grosse Pointe Shores. It was demolished in 1970. (Courtesy of a Private Donor.)

112

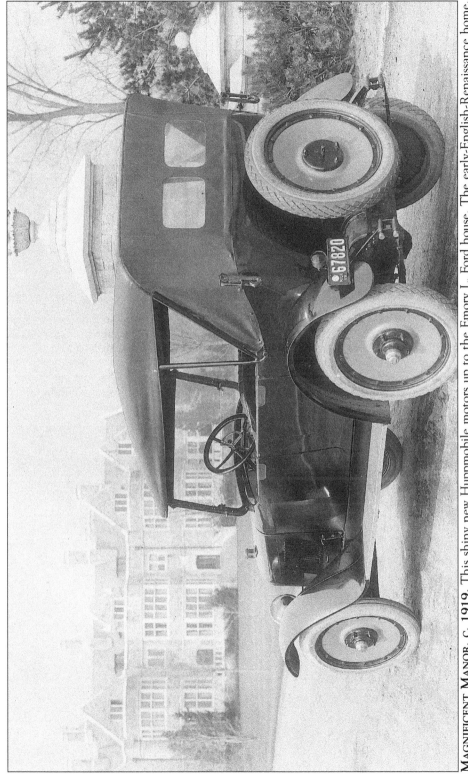

MAGNIFICENT MANOR, c. 1919. This shiny new Huppmobile motors up to the Emory L. Ford house. The early-English-Renaissance home, on Lake Shore Road near Woodland Shores Road in Grosse Pointe Shores, was completed in 1916 and demolished in the 1950s. (Courtesy of George O. Young Jr.)

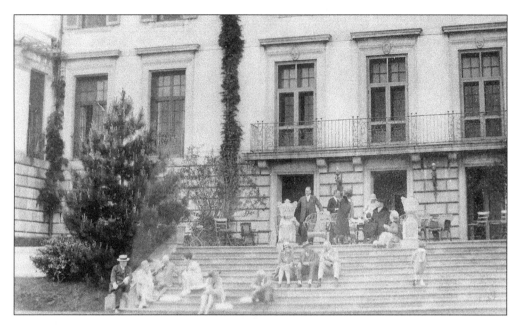

TEA TIME, C. 1929. With a staff of 19 servants to operate their opulent home, The Moorings, on Lake Shore Road near Elm Court in Grosse Pointe Farms, the Russell A. Alger Jr. family could easily entertain in style. Russell A. Alger Jr., seated third from right, was wheelchair-bound after being thrown from his horse while hunting. His wife Marion stands behind him serving tea. The Great Hall of the The Moorings was primarily used as a reception room. Decorated in the style of the times, the room featured floor to ceiling tapestries and tiger-skin rugs. (Courtesy of the Grosse Pointe War Memorial Association Collection.)

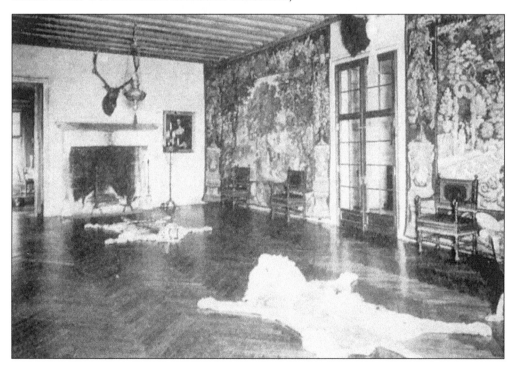

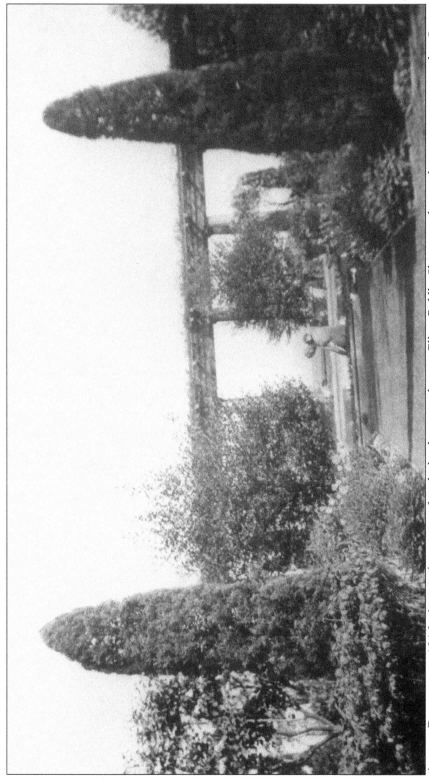

ALGER GARDEN, c. 1916. America's premier, female landscape-architect, Ellen Biddle Shipman, designed many projects in the Grosse Pointes including the elegant formal gardens of the Russell A. Alger Jr. estate, The Moorings. The Italian-Renaissance villa was designed by Charles A. Platt and completed in 1910. Following Alger's death, the estate became an annex for the Detroit Institute of Arts. In 1949 it became a community center honoring servicemen, known as The Grosse Pointe War Memorial. (Courtesy of the Grosse Pointe War Memorial Association Collection.)

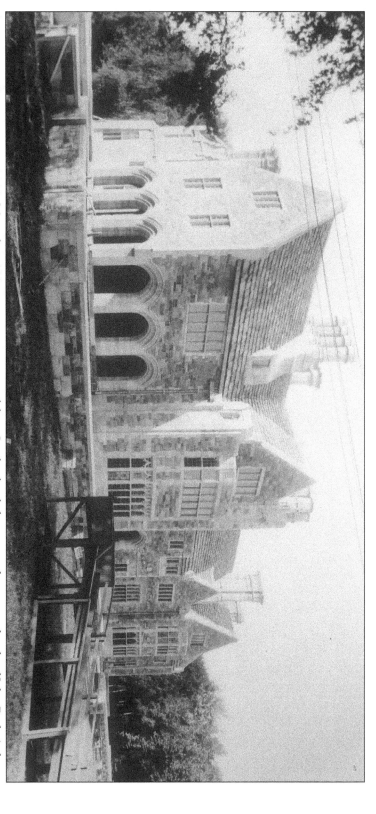

ABANDONED GRANDEUR, C. 1919. More than 100 stone cutters imported from Scotland toiled to create the granite façade of John Dodge's dream house, on Lake Shore Road and Harbor Hill in Grosse Pointe Farms. Designed in 1918 by Smith, Hinchman, and Grylls, the mansion aspired to be the largest home in Detroit, boasting 110 rooms. The estate also included a greenhouse, swimming pool, a labyrinth of underground storage tunnels, and a man-made peninsula jutting out into Lake St. Clair where Dodge could moor his yacht. Tragically, on January 14, 1920, the dream died with John Dodge. Construction was abandoned and many of the architectural details and fittings were installed in Meadowbrook Hall in Rochester Hills, Michigan, the home Matilda Dodge built with her new husband Alfred G. Wilson. The ghostly shell of the mansion loomed over Lake St. Clair until it was demolished in 1940. For several years, the property was used as a summer day-camp prior to becoming the Harbor Hill residential subdivision. In 1970, a gas leak filled leftover underground tunnels, causing an explosion that destroyed one house and heavily damaged two others. Miraculously, no one was injured. The tunnels were later sealed. (Courtesy of the Grosse Pointe Historical Society.)

116

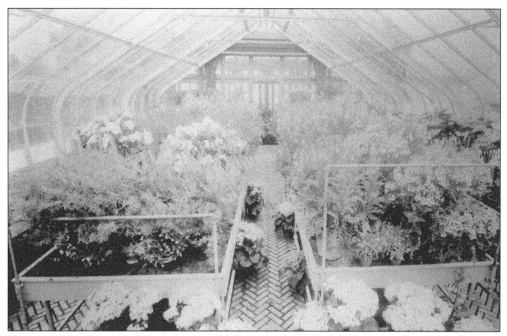

BLOOMING BUSINESS, C. 1920. Vincent DePetris traveled from Belgium to care for the gardens and greenhouse at the new Lakeshore Road estate of Mr. and Mrs. John Dodge. After Mr. Dodge's death in 1920, DePetris was granted permission to run a commercial floral business out of the abandoned estate's greenhouse. The business closed in the early 1960s, but he eventually purchased a portion of the surrounding property now known as DePetris Way. (Courtesy of the Grosse Pointe Historical Society.)

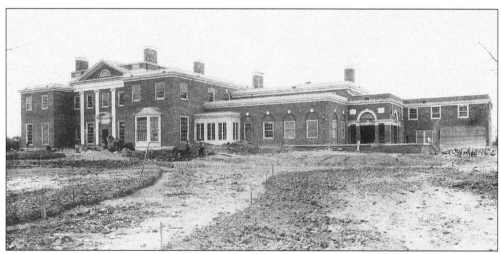

HISTORIC HEDGES, C. 1927. This Georgian mansion designed by John Russell Pope was built for Roy D. Chapin, president of the Hudson Motor Car Company, on Lake Shore Road at Windemere Place in Grosse Pointe Farms. Esteemed landscape architect Bryant Fleming laid out a garden for Mrs. Chapin that included 600-year-old yew hedges imported from England. In later years, the house was the home of Mr. and Mrs. Henry Ford II. It was demolished in 1983, but the pool survives as part of the Windemere detached condominium development. (Courtesy of the Grosse Pointe Historical Society.)

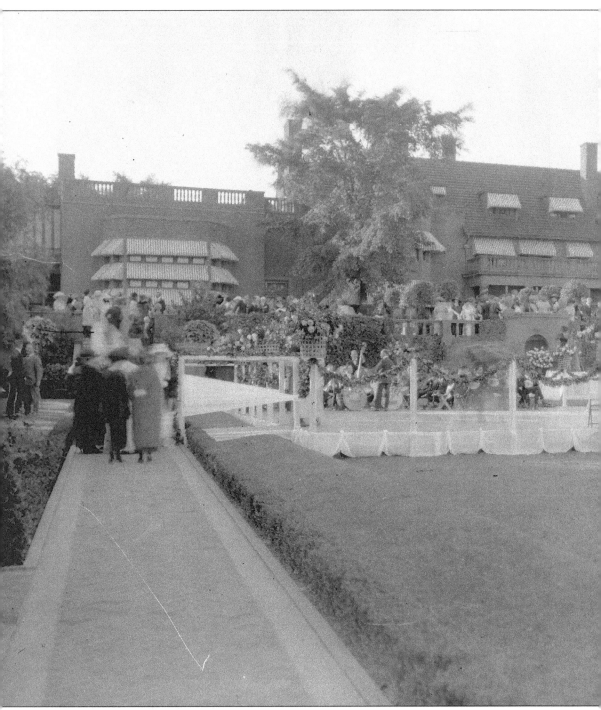

ROSE TERRACE, C. 1921. Guests mingle at a party hosted by auto baron Horace Dodge. When the Dodge brothers' rowdy reputation precluded Horace's immediate acceptance into the Country Club of Detroit, he reportedly evened the score by purchasing the adjoining property, at Lake Shore Road and Rose Terrace in Grosse Pointe Farms. Noted industrial architect Albert Kahn was then commissioned to build a mammoth early-English-Renaissance mansion to dwarf

the neighboring clubhouse. In 1910, the family moved into the home, backed by terraced rose gardens, where they enjoyed such creature comforts as a gymnasium, pipe organ, and a dock for Horace's yachts. When the widowed Anna Dodge later remarried, this house was demolished to make way for her new home. (Courtesy of the Detroit News Collection/Walter P. Reuther Library, Wayne State University.)

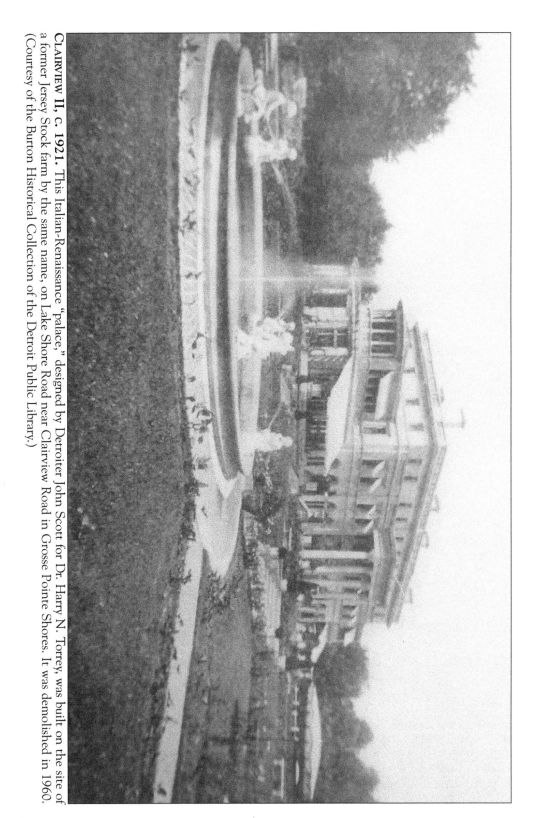

CLAIRVIEW II, c. 1921. This Italian-Renaissance "palace," designed by Detroiter John Scott for Dr. Harry N. Torrey, was built on the site of a former Jersey Stock farm by the same name, on Lake Shore Road near Clairview Road in Grosse Pointe Shores. It was demolished in 1960. (Courtesy of the Burton Historical Collection of the Detroit Public Library.)

SUMPTUOUS SURROUNDINGS, C. 1916. As this photo of their drawing room illustrates, Dr. Harry N. Torrey and his wife Eleanor Ford Torrey created a sumptuous setting for entertaining the *crème de la crème* of international society at Clairview II, their home on Lake Shore Road near Clairview Road in Grosse Pointe Shores. According to newspaper accounts, royalty and statesmen danced across its marble floors. Dr. Torrey, a noted surgeon, yachtsman, and big game hunter, hosted a medical convention for 1,200 at the mansion in 1916. The house burned in 1959 and was demolished in 1960. (Courtesy of the Burton Historical Collection of the Detroit Public Library.)

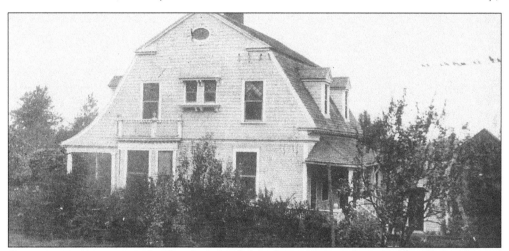

GAUKLER POINTE, C. 1920. This frame and shingle cottage stood on Gaukler Pointe, located near the northern-most tip of Grosse Pointe Shores, when auto baron Henry Ford purchased the property from Josephine Gaukler in 1914. He intended to live there while building a great estate on the land. But the genius who put the world on wheels found his prospective neighbors "damn stiff-necked" and less than welcoming. So he opted to construct his home, Fairlane, in Dearborn—the Detroit suburb where he spent most of his youth. For many years, Ford allowed his Detroit neighbors, Mr. and Mrs. Gore and their daughter Helen Gore Doremus, to use this house as a cottage. When the property was sold to Henry's son Edsel Ford in 1927, the house was moved to its present site on Doremus Avenue near E. Jefferson Avenue in St. Clair Shores. Gaukler Pointe was named for Roseville, Michigan, merchant Jacob Anthony Gaukler who summered there with his family since 1876. In 1917, innkeeper Matt Kramer built a popular roadhouse on a portion of the land. (Courtesy of the Henry Ford Museum/Greenfield Village Archives.)

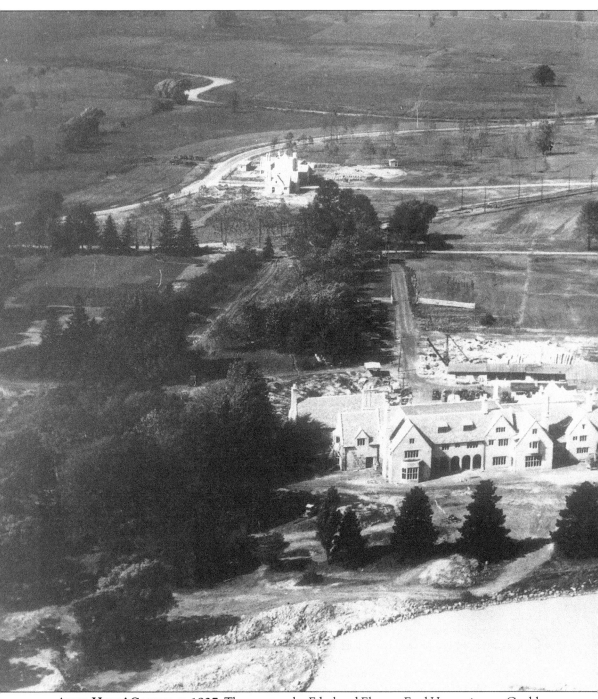

AUTO HEIRS' CASTLE, C. 1927. The spectacular Edsel and Eleanor Ford House rises on Gaukler Pointe in Grosse Pointe Shores. Edsel, only son of auto pioneer Henry Ford and his wife Eleanor Clay Ford, acquired the property from his father in 1927. The main house and gatehouse, designed in the English Cotswold style by famed architect Albert Kahn, were completed in 1929. The 300-acre grounds were designed in the "prairie school" style by American landscape architect Jens Jensen. A child-size playhouse was later added as a gift from Mrs. Henry Ford

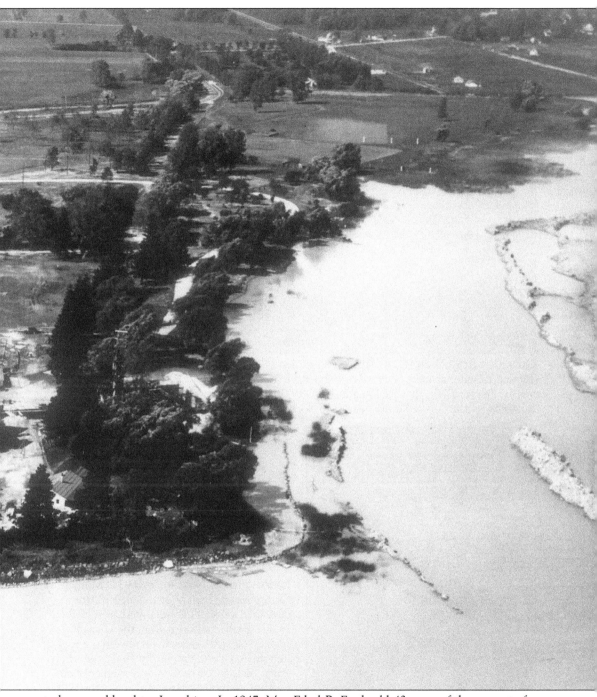

to her granddaughter Josephine. In 1947, Mrs. Edsel B. Ford sold 43 acres of the property for $60,000 to the City of Grosse Pointe Woods to establish its Lakefront Park. Mrs. Ford, who died in 1976, opened the estate for public use as part of a bequest, which included a trust for the property's maintenance. It is currently listed on the State and National Registers of Historic Sites and is open for tours and special events. (Courtesy of the Henry Ford Museum/Greenfield Village Archives.)

GLORIOUS ROSE GARDEN, C. 1921. The garden of automotive pioneer Horace Dodge's Rose Terrace I estate, at Lake Shore Road and Rose Terrace Road in Grosse Pointe Farms, fitted out for Horace Dodge Jr.'s wedding in its party finery only a freshly minted fortune could buy. (Courtesy of the Grosse Pointe Historical Society.)

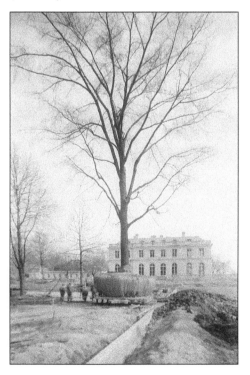

IMPROVING ON NATURE, C. 1931. Mother Nature was no match for the elegant whims of Anna Dodge, widow of auto baron Horace Dodge. Skilled arborists from the Chas. F. Irish Company reset many a towering tree, like this 100-foot elm, in the landscape when Anna built an 18th-century French chateau to share with her second husband actor/realtor Hugh Dillman. Designed in the style of the Petit Trianon at Versailles, the house replaced Horace Dodge's Rose Terrace on the 8.8-acre estate at Lake Shore Road and Rose Terrace in Grosse Pointe Farms. (Courtesy of the Chas. F. Irish Company Collection.)

THE END, C. 1905. Taking the Pointe's code of understated dress to extremes, this infant offspring of a summer colony family surveys her gilded world from the serene safety of her family's veranda. In keeping with the local deference for polite discretion, she will remain nameless. However, we can tell you that she spent more than 90 years in Grosse Pointe and witnessed her view transformed. As she grew, the last vestiges of the old French farming village faded away and the cottages and roadhouses were torn down to make way for grand estates. Eventually many of these too passed into history, making way for elegant tree-lined subdivisions. But for all the changes, the things that really counted remained the same … natural beauty and an unpretentious, neighborly spirit still makes Grosse Pointe a wonderful place to call home. (Courtesy of the Grosse Pointe Historical Society.)

BIBLIOGRAPHY

Agresta, David and Caroline Latham. *Dodge Dynasty: The Car and the Family that Rocked Detroit*. Chestnut Hill, MA: Harcourt Brace Jovanovich, 1989.

Bingay, Malcolm. *Detroit is My Own Hometown*. Indianapolis, IN: The Bobbs-Merrill Company, 1946.

Boni, Margaret, ed. *Fireside Book of Favorite American Songs*. New York, NY: Simon and Schuster, 1914.

A Brief History of the Grosse Pointe Public School System. Pamphlet. Grosse Pointe, MI: Grosse Pointe Public School System, January-February 1997.

A Chronology of Grosse Pointe Woods VI. Booklet. Grosse Pointe Woods, MI: Grosse Pointe Woods Historical Commission, 1998.

Farmer, Silas. *Grosse Pointe on Lake Sainte Claire*. 1886. Reprint. Detroit, MI: Gale Research Company, 1974.

———. *History of Detroit and Wayne County and Early Michigan*. 1890. Reprint. Detroit, MI: Gale Research Company, 1969.

Ferry, W. Hawkins. *The Buildings of Detroit*. Detroit, MI: Wayne State University Press, 1968.

———. *The Mansions of Grosse Pointe*. Michigan Society of Architects, 1956.

Fisk, Margaret Cronin. *Living the Values: The Sisters of Bon Secours in Michigan 1909–1989*. Grosse Pointe, MI: Bon Secour, 1989.

Furtaw, Col. William. *A Short History of the Grosse Pointe Park Police and Fire Departments*. Grosse Pointe, MI: Grosse Pointe Park Police Department, 1980.

Grosse Pointe Farms Historical Advisory Commission. *A Walk Though Time, The History and Heritage of Grosse Pointe Farms*. Grosse Pointe:, MI: Grosse Pointe Farms Foundation, 1993.

Hamlin, Marie Caroline Watson. *Legends of Le Detroit*. Detroit, MI: Thornidke Nourse, 1884.

Hayes, Walter. *Henry: A Life of Henry Ford II*. New York, NY: Grove Weidenfeld, 1990.

Henning, Jack E., Schramm, William H. "Detroit's Street Railways City Lines; Vol. I 1863–1922." *Bulletin #117*. Chicago, IL: Central Electric Rail Fan's Association, 1978

Hirsch Jr., E.D., Kent, Joseph F., and Trefil, James. *The Dictionary of Cultural Literacy*. Boston, MA: Houghton Mifflin Company, 1988.

Kliber, Ralph J. and Margie Reins Smith. *A Beacon of Tradition: The Complete History of the Grosse Pointe Yacht Club*. Booklet. St. Clair Shores, MI: Kelvin Publishing, 1986.

League of Women Voters of Grosse Pointe. *Know Your Grosse Pointe*. Grosse Pointe, MI: League of Women Voters of Grosse Pointe Fund, 1992.

Lodge, John C. *I Remember Detroit*. Detroit, MI: Wayne State University Press, 1949.

Luedtke, Eleanor. *In Good Company; A Centennial History of the Country Club of Detroit, 1897–1997*. Grosse Pointe, MI: Country Club of Detroit, 1997.

Mason, Philip P. *Rum Running and The Roaring Twenties: Prohibition on the Michigan-Ontario Waterway*. Detroit, MI: Wayne State University Press, 1995.

Mecke, Theodore H. *A Brief History of St. Paul's Parish, 1884–1984*. Pamphlet. Grosse Pointe, MI: St. Paul Church, 1984.

Moore, Kenneth L. "A Brief History of Grosse Pointe 1679–1975." *The Grosse Pointe News*. Grosse Pointe, MI: First Federal Savings of Detroit, The Grosse Pointe Public Library, 1975.

Moran, J. Bell. *The Moran Family: 200 Years in Detroit*. Detroit, MI: Alved of Detroit Inc., 1949.

Painter, Patricia Scollard. *A Community History*. Grosse Pointe, MI: DEAR, 1981.

The Past as Prologue, 1900–Present. Writ., dir., and prod. by Kimberly Conely. Videocasette. Grosse Pointe Historical Society Videos: 1993.

Pointe to Pointe, A Tour of East Jefferson-Lake Shore Road from Windmill Pointe to Gaukler Pointe. Booklet. Grosse Pointe, MI: Grosse Pointe Historical Society, 1987.

Quaife, M.M. *This is Detroit*. Detroit, MI: Wayne University Press, 1951.

Recollections of the Past, 1650–1900. Writ., dir., and prod. by Kimberly Conely. Videocasette. Grosse Pointe Historical Society Videos, 1995.

Socia, Madeleine. *Academy Magazine: Celebrating 25 Years*. Grosse Pointe, MI: The Grosse Pointe Academy, December 1994.

The Village of Grosse Pointe Farms 1893–1922. Pamplet. Grosse Pointe, MI: Township of Grosse Pointe, 1922.

Woodford, Arthur M., ed. *Tonnancour: Life in Grosse Pointe and along the shores of Lake St. Clair, Vol.1 and 2*. Detroit, MI: Omnigraphics, Inc., 1994.

W.P.A. Federal Writers' Project. *The Grosse Pointe Guide*. Detroit, MI: Detroit Field Office, 1936.

CPSIA information can be obtained
at www.ICGtesting.com
Printed in the USA
LVHW101556110219
607141LV00015B/401/P

9 781531 605209